HAUNTED MARIETTA

HAUNTED MARIETTA

HISTORY AND MYSTERY IN OHIO'S OLDEST CITY

LYNNE STURTEVANT

Haunted America

Published by Haunted America
A Division of The History Press
Charleston, SC 29403
www.historypress.net

First published 2010
Second printing 2011
Third printing 2012

Cover image: Washington County Courthouse. Photo by Michael Pingrey.

Manufactured in the United States

ISBN 978.1.59629.948.1

Library of Congress Cataloging-in-Publication Data

Sturtevant, Lynne.
Haunted Marietta : history and mystery in Ohio's oldest city / Lynne Sturtevant.
p. cm.
ISBN 978-1-59629-948-1
1. Ghosts--Ohio--Marietta. 2. Haunted places--Ohio--Marietta. I. Title.
BF1472.U6S88 2010
133.109771'98--dc22
2010026636

The Supernatural is the Natural, just not yet understood.

—*Elbert Hubbard*

CONTENTS

THE MOST HAUNTED TOWN IN OHIO

Intelligent spirits, residual vibrations, emotionally charged objects—the supernatural meanders through our lives largely unnoticed. The paranormal is part of our environment, but in most places the din of traffic, construction equipment, car alarms, jackhammers and sirens renders the more subtle vibrations of the unseen world undetectable. Add the energetic interference of microwaves, GPS satellites, cellphones and radio and TV signals and it's a wonder anyone can sense the supernatural at all.

But things are different in Marietta. The echoes of the past are strong here, and the spirits of those who lived long ago remain. They inhabit a dimension beyond time—the realm of dreams and memory, of history and imagination—and their stories are as close as a whisper for those who are willing to listen.

IN THE BEGINNING

It all started over tankards of ale. The year was 1786, and March was roaring into Boston like an angry lion. Sleet pelted the windows of the Bunch-of-Grapes Tavern as the soaked Revolutionary War veterans took

their places around the table. General Rufus Putnam called the meeting to order, and the boisterous group quickly quieted down. Putnam still commanded respect.

Five years had passed since the British surrender at Yorktown, and the war was fresh in the soldiers' minds. For some, its images would never fade. But the former comrades in arms had not gathered on this wild and windy night to rehash skirmishes with the redcoats, toast acts of American patriotism or remember their fallen brothers. They had come to the Bunch-of-Grapes to talk business.

Before the night was over, the veterans had created the Ohio Company of Associates and formulated a plan to migrate as a group and to establish a settlement in the western wilderness. There was much to do. They needed to issue stock, raise money, recruit new members and obtain legal titles and authorizations from the Continental Congress. The list of tasks seemed almost endless. Undaunted, they ordered another round of ale, elected Rufus Putnam as superintendent of their new organization and got to work.

Less than two years later, forty-eight members of the Ohio Company boarded oxcarts in Ipswich, Massachusetts, and headed west. When the group reached Pittsburgh, they transferred to a flat-bottomed boat appropriately named the *Adventure Galley* and sailed down the Ohio River. In April 1788, they arrived at the mouth of the Muskingum River. With Putnam in the lead, the men climbed ashore and founded the first settlement in the Northwest Territory. They named it Marietta to honor French queen Marie Antoinette's support of the colonists during the American Revolution.

Putnam and his associates assumed that Marietta would be the first choice for capital of the Northwest Territory. But they did not plan to accept that honor. The men of the Ohio Company had a more ambitious goal. They wanted Marietta to become the capital of the United States, and they planned the city accordingly.

They laid out the town in a grid pattern, like a New England village, with an eye to grand public spaces, education and culture. The group took steps to protect the ancient earthworks that dotted the area and even gave them imposing Latin names. The pyramid mound became Conus because of its shape. The largest platform mounds were named

the Capitoleum and the Quadranou, and the walled walkway from the Muskingum River was christened the Sacra Via. They didn't stop there. The settlers named the fort they constructed to protect themselves from the increasingly hostile Native Americans the Campus Martius, and the muddy little creek that ran through the center of what would become downtown became the Tiber.

Marietta wasn't chosen to be capital of the United States; it didn't become the capital of the Northwest Territory, either. It didn't even become the capital of Ohio. But it did thrive and develop into a pleasant and successful town. It has survived Indian wars, epidemics, devastating floods, tornados and fires. Its citizens have fought and died in every war. The town has produced business tycoons, politicians, social reformers, diplomats, musicians and heroes who risked their lives to shelter fugitive slaves. It has also spawned con artists, child molesters, bank robbers, philanderers and men who drowned their wives in the Ohio River.

Marietta is a paradox. A lot has happened here, and nothing has changed. The town's layout is essentially the same as it was in the days

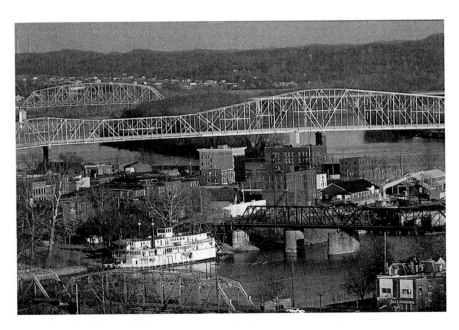

Marietta in the 1980s. *Courtesy of the Washington County Historical Society.*

of the Ohio Company. New buildings have been added, of course, and old ones have disappeared, but Marietta's main features have remained remarkably stable through the years. If Rufus Putnam dropped in for a visit, he could easily find his way around.

The accumulated emotional energy of the past remains, too. The murders, the suicides, the river disasters, the hopes, the broken hearts, the disappointments—all the joys and tragedies of those who lived and died here float just beneath the surface of everyday life. The energy bubbles up all over town, sometimes manifesting in the most unexpected places and ways. Supernatural encounters, unexplained incidents and paranormal phenomena are so common that they're almost routine. Almost, but not quite.

THE SUPERNATURAL DECODED

Ghost stories and reports of paranormal activity are not the same. Ghost stories are fictional creations that include a ghost or ghosts as characters. Ghost stories—good ones, in any case—are dramatically satisfying. They have beginnings, middles and ends. Many feature surprise closing lines, such as: "And the next morning we found out he had died in 1899!" Any story that is too perfect, has a moralistic message or tone or involves a stock character (such as a spectral hitchhiker, a girl who needs a ride to the prom or a chain-rattling skeleton) is suspect.

Paranormal incident reports, on the other hand, don't have a dramatic arc. They have something much more compelling: the ring of truth. A typical report goes like this: I felt weird when I walked into the room, like someone was watching me, even though I was sure I was alone in the house. I sat down on the couch and reached for my book, but it wasn't on the coffee table. The odd thing is, I know I left it there. I distinctly remembered putting it on the table about an hour earlier. I looked everywhere, but it didn't turn up, so I went for a walk. When I came home, my book was on the coffee table, right where it should have been. I swear it wasn't there before I went out.

The unexplained disappearance and reappearance of objects is known as the borrower phenomenon, and it happens constantly all over Marietta. A few other common indicators of supernatural activity include unexplained noises, such as footsteps, knocks, taps and bangs; doors, drawers and windows opening and closing on their own; lights, ceiling fans and appliances turning themselves off and on; mysterious shadows; cold spots; and pets that see, hear or are frightened by things their owners can't detect.

Just as there are different types of paranormal indicators, there are also different types of supernatural entities. Intelligent hauntings are what most people are referring to when they talk about ghosts. Intelligent entities are aware and can interact with humans, animals and the environment in various ways. They may touch you, materialize before your eyes, speak or cause a warm, peaceful vibration to flow through your body. Some intelligent spirits are associated with particular aromas, such as cigar smoke, sizzling bacon or perfume. Others connect by causing cold chills, shortness of breath or the heebie-jeebies. Intelligent entities are unpredictable. They are also mobile. You may hear or see something in your basement and, a few days later, have the same experience in the attic. There are dozens of well-documented intelligent hauntings in Marietta, many of which will be discussed in detail in the following pages.

Poltergeists fall into a special category. Much loved by Hollywood and horror authors, poltergeist infestations involve odd noises, objects moving on their own and assaults on people or animals. Most psychologists and serious paranormal investigators do not consider poltergeist activity to be supernatural in origin. They believe that the disruptions are unintentionally generated by living people who are under extreme stress. In the past, poltergeist activity was often attributed to adolescent girls. It is now understood that anyone of any age can be the source.

Residual hauntings are the most common supernatural phenomenon. Even though encountering one can be terrifying, residuals are not ghosts. They are energetic echoes of emotionally intense events that replay over and over. They are predictable, consistent and unchanging, never varying in any way. Residuals are often compared to stuck records or endlessly repeating tape loops. They are not aware; they do not interact

with people or the environment. Some manifest at the same time each day. Others are triggered by weather conditions, such as thick fog or predawn thunderstorms.

The following classic English ghost story is actually a description of a residual haunting: There is a grey lady in the castle. She appears in the hallway every morning at two o'clock. She walks the length of the hall and starts to descend the grand staircase. When she reaches the third step, she disappears.

Most of us have encountered residual emotional energy. It is the tension described as "thick enough to cut with a knife" that lingers in a room where people have been arguing. A residual haunting is the same impulse on a larger, longer-lasting and more intense scale.

Because residual hauntings are frequently associated with murders and other violent events, some mistakenly believe that only negative incidents can spawn them. It does not matter whether the precipitating event is positive or negative. It is the level of emotional intensity that generates the haunting. It is true that battlefields, hospitals and nursing homes often contain thick layers of residual energy, but so do churches, libraries and theatres.

Residual energy can embed itself into physical matter, such as the walls of buildings. This explains why residuals are stationary. They become part of the environment; they never migrate. Embedded residuals are behind the majority of haunted house reports.

Buildings aren't the only elements in the physical world that absorb energy; small objects can be affected, too. Unlike the dramatic emotional explosions that cause residual activity in buildings, this phenomenon is subtler, quieter. A beloved toy, a favorite painting or an heirloom necklace can absorb the feelings and emotions that its owner projects onto it. The energy can then be sensed by others, sometimes years later. It is what a psychic tries to detect when she holds a missing person's keys and attempts to determine whether that person has been the victim of a crime.

Studies of this phenomenon, known as psychometry, tend to focus on items that people have owned for decades or on antiques, but the staff at Schafer Leather Store on Front Street regularly sees brand-new items become energized. A browser enters the store and is drawn to a gorgeous

purse. She picks it up, caresses the soft leather, places her arm through the strap and gazes at her reflection in the full-length mirror. It's obvious from her smile that she likes what she sees. She walks around the store looking at the boots, jackets, wallets and jewelry, all the while cradling the bag close to her body. Eventually, she sighs, removes the bag from her shoulder, gingerly places it back on its hook and leaves. The next person who walks into the store will make a beeline for the same bag, pick it up and buy it.

Rough Crossings

Most people make the transition from this life to whatever is next without difficulty. A few, however, fail to cross over. The reasons these individuals linger are varied, complex and not well understood, but all delayed crossings involve an unwillingness or inability to let go of the earthly plane.

People who have invested enormous amounts of time and energy into amassing material goods—houses, bank accounts, jewelry, cars—sometimes cannot accept the "you can't take it with you" aspect of dying. Their fierce attachment to their physical possessions shackles them and prevents them from moving on. A variation on this theme involves people who will not leave work. This is primarily an issue with self-made men and women who have built businesses from the ground up. In life, these are the people who cannot delegate, who never take a vacation, never call in sick and cannot relinquish control. Their psychic connections to their careers or businesses are so strong that not even the Grim Reaper can dislodge them from their desks. This type of attachment underlies much of the activity in the Lafayette Hotel and the Anchorage and may be a factor at the Mid-Ohio Valley Players and Colony Theatres as well.

Others remain because of emotional ties to those who are still living. Examples include mothers who leave babies behind, children who precede their parents in death and spouses who wait for their partners so they can cross over together. The living often sense the presence of these

spirits at important family events, such as funerals, holiday celebrations and weddings. They complete their crossings as soon as they are reunited with their loved ones.

As a motivator, fear is almost as powerful as love. Criminals and those who regret things they've done in life are often terrified of death. They worry they'll be judged, as many religious traditions teach, found guilty and sentenced to eternal punishment. The fear intensifies as the final minutes of life tick away. For some, this unchecked terror completely blocks the path between this world and the next, leaving them hopelessly stuck and unable to move forward.

A popular type of ghost story features a person who returns from the dead to complete unfinished business. Crime victims seeking justice and those who need to reveal the locations of hidden objects or documents, especially wills, are particularly common. Anything is possible, of course, but the combination of a well-structured story and a compelling ending is always suspicious. This does not mean that unfinished business cannot be a powerful motivator. The story of the Anchorage and Eliza Putnam's thwarted desires is a case in point.

Authentic ghost reports almost always involve the spirits of people who died within the last few hundred years. Contact with those who lived thousands of years ago is extremely rare. It seems that everyone, even the most reluctant, eventually manages to cross over. Perhaps this happens when everyone with whom the earthbound spirit had any connection is gone, and the physical world, once so safe and familiar, becomes a lonely, confusing and hostile place.

GHOST HUNTING 101

The ranks of paranormal investigators have increased dramatically over the last decade. Several factors have contributed to this growth, including popular television shows, Internet sites and the availability of technological devices especially designed for supernatural detectives. Digital voice recorders pick up EVPs, or electronic voice phenomena,

spirit sounds that vibrate beyond the range of human hearing. Likewise, infrared video cameras capture images invisible to the naked eye. Cold spots, a classic indicator that a supernatural entity is present, can be measured and documented by sophisticated thermometers that rely on lasers. And handheld devices such as EMFs, or electromagnetic field detectors, register the magnetic energy spikes frequently associated with paranormal activity.

The most popular ghost-detecting device is the digital camera. Patience, persistence and common sense are all you need to capture photos of anomalies, such as the vaporous clouds called graveyard mists and the bright soap bubble–like spheres known as orbs. Make sure your camera's lens is spotless. Keep hair, camera straps and fingers out of the way and be aware of the temperature, especially when you're shooting outdoors. If the air is cool, the camera may pick up your exhalations as a weird hazy field. Cigarette smoke and campfires, even at a distance, can cause the same effect.

You are most likely to capture orbs while shooting in dim light or darkness. But remember, your flash will reflect off elements in the environment such as dust, mist, drizzle, snow, pollen, insects and shiny surfaces. All of these reflections, which are called backscatter, look exactly like orbs. The easiest way to determine whether backscatter is a factor is to take several shots of the same subject in rapid succession. Aim your camera and shoot—click, click, click—without changing your position at all. If the shots all contain the same odd feature in the same place, it's probably something natural in the environment. If, on the other hand, the anomaly appears in only one shot or moves around, further investigation is called for. Never delete pictures until you have downloaded them onto a computer and examined them carefully.

Some people believe oddities turn up in modern digital photos because cameras are much more sophisticated than they used to be. However, the main reason you don't see orbs in the old family photo album has nothing to do with equipment enhancements or the paranormal. It has to do with the way film used to be processed. Prior to the digital revolution, rolls of exposed film were sent to labs for developing. Photographers paid only for the prints they wanted. Lab technicians routinely discarded images that

These orbs are actually pollen. *Photo by Lynne Sturtevant.*

were blurry, too dark, too light, chopped people's heads off, contained close-ups of fingertips or contained orbs and other odd features. No one outside the lab ever saw these "defective" photos.

Any technological device can produce a false reading. Almost all of the weird sounds on voice recorders and the anomalies picked up by various other instruments have nonsupernatural sources. Legitimate, serious investigators strive to debunk so-called evidence of ghosts, efforts that make the remaining cases, the ones that cannot be explained, all the more intriguing.

EMF detectors and K2 meters are especially unreliable in old buildings, where exposed wiring, circuit boxes and even appliances can cause gauges to fluctuate wildly. Since ghost hunters and other investigators tend to spend a lot of time in older structures, this is a very serious issue. The presence of excess electrical energy in enclosed spaces, from whatever source, can also cause many of the sensations associated with ghost encounters, including tingling, chills and goose bumps; a crawling

sensation on the scalp, arms and legs; and the impression that someone is watching you. What feels like a ghost may be a microwave with a ruptured seal. It is critical that you learn as much as you can about the environment before coming to any conclusions.

Dozens of books and websites explain how to conduct a paranormal investigation. They cover everything from what equipment to bring to what to wear. Some even specify what types of snacks investigators should—and should not—eat. But very few describe how to find an appropriate location to investigate. Where does one look for spirits? Thanks to horror movies, many first-time ghost hunters head straight for the nearest cemetery. A few lost souls may linger in graveyards, but you are more likely to encounter supernatural entities where groups of people congregate. Bars, hotels, churches and theatres are good possibilities. Ghosts of the intelligent variety often return to or remain in places where they were happy. Residuals, on the other hand, are tied to the places where the incidents that generated them occurred.

Local legends and ghost stories contain valuable clues. Some tales, of course, are pure fiction. But others, even if they've been embellished and changed through endless retelling, may be worth investigating. Most newspapers run stories around Halloween about local ghosts, haunted houses, and other unexplained phenomena. The scenes of spectacular historical murders, especially those categorized as crimes of passion, should be looked into. Check your library's archives. This requires a bit of digging, but the results can be well worth the time and effort.

Buildings constructed over water sources should be considered, too. The Druids, high priests of the ancient Celts, believed that springs and subterranean streams attracted spirit energy and served as conduits between our world and the realm of the dead. We now know that the ghostly attraction extends to man-made underground water features, such as wells, cisterns and sewage and drainage systems. Underground water is a factor at several of Marietta's most notorious haunted locations.

A final note on ghost hunting relates to the attitude and expectations you bring to the experience. Technological devices are amazing, but they can be a hindrance if their operation takes your attention away from what is happening around you. The most valuable asset you can bring to

a haunted location is not a digital camera; it is a quiet, open mind. Stay present, patient, centered and alert. Don't try to force an encounter, and don't assume that things will happen the way you expect them to. Relax and allow the situation to unfold and develop. Above all, have compassion and show respect. Ghosts are not figments of your imagination. They are real people, albeit in a different form, and they are waiting at the threshold of your awareness.

Open the door.

WAITING IN THE WINGS

In the early 1900s, there were five successful live-performance theatres in downtown Marietta. The two that remain—the Mid-Ohio Valley Players, or MOVP for short, and the Colony—have much in common. They are located within the same block of Putnam Street. They are of similar age: the MOVP Theatre, originally called the Putnam, was built in 1914; the Colony, originally known as the Hippodrome, opened in 1919. Each functioned as a movie theatre as well as a vaudeville house, showcasing variety acts, stage plays and concerts. Both the MOVP and the Colony are also haunted, possibly by the same ghost.

High levels of supernatural activity are common in theatres. Intense energy gathers on stages and in dressing rooms, balconies and corridors. The echoes of the actors' feelings—the emotions they summon in order to perform, the stage fright, the thrill of the applause, the humiliation of forgotten lines—mingle with the vibrations of the fantasy worlds they create. And sitting in the dark, taking it all in, are the members of the audience, each one embracing the magic and adding to the supercharged atmosphere. Like river sediments, these layers of energy accumulate show after show, night after night, year after year.

THE MID-OHIO VALLEY PLAYERS THEATRE

The MOVP has been home to Marietta's community theatre group since 1977. The vibrant and lively troupe uses the old theatre for auditions, rehearsals and meetings; to work on props, scenery and costumes; and, of course, for performances. There is a constant flow of people in, out and around the building, and an astonishing number of them have had encounters with the unexplained. They are reliable, normal, rational people who serve on juries, chair PTA meetings and volunteer at the Humane Society. It's risky to claim you've seen a ghost or have been touched by invisible hands, especially when you live in a town where everyone knows everyone else. But witnesses continue to step forward.

Not surprisingly, many of the odd things that happen in the MOVP revolve around the performances. Actors often feel what they refer to as a presence while on stage. It is as if someone is directly behind them as

The Putnam Theatre, now known as the MOVP. *Courtesy of the Washington County Public Library.*

they speak their lines. They feel the cool breath on their necks, the flutter of fingers brushing their backs. One woman was patted on the rump!

The presence, whoever he or she is, seems to have an issue with theatrical props. They disappear from the prop room and turn up in unexpected places later, when they are no longer needed. They are also frequently jumbled. At a critical moment in the final scene of a comedy, the leading lady was to knock a silver teapot from a small table. The stage manager checked the placement of all the props—including the teapot—twice before the curtain rose. Everything was in order, until the actress reached for the teapot and found a muddy work boot on the table instead. On other occasions, the correct props were there, but they were in the wrong places. It's as if someone follows the stage manager as she sets things up and rearranges everything as soon as she turns her back.

Costumes are another favorite target. One of the actresses had car trouble on her way to the theatre on opening night. She arrived late and frazzled. She hung her costume, a long sequined gown, on the back of the dressing room door and ran down the hall to use the restroom before getting dressed. Even though she was away less than three minutes, when she returned, her gown was gone. In a complete panic, she recruited the rest of the company and crew, and they searched the theatre. They didn't find the dress. It was almost curtain time, so they did the best they could with a tablecloth, pins, duct tape and a feather boa. The play was a huge hit, and the audience probably never realized anything was amiss in the costume department. But the mystery of the dress's location stayed with the cast and crew. A month later, a volunteer carpenter who was building a set for the next production found the gown stuffed in a tool chest in the basement.

Seamstresses, who spend hours altering garments to make them fit a variety of body types, often find hems torn out, seams ripped apart, pins and scissors scattered over the floor and thread, fabric and buttons lying in heaps. Sometimes even audience members have odd experiences in the MOVP. A woman slipped out of a performance one evening to use the facilities. She walked into the empty ladies' room and watched in amazement as a fresh roll of toilet paper started spinning on its own. It didn't stop until all the paper had unfurled onto the floor.

The activity inside the MOVP extends beyond the disruption of physical objects. Many people, including cast, crew and family members, have seen ghosts, and their descriptions over the years have been remarkably consistent.

The first apparition is a tall middle-aged man who wears a brown derby hat. The conventional wisdom is that this is the spirit of Mr. Shea. He was the president of the Shea Theatre Company, a firm that owned and operated theatres throughout southeastern Ohio. Although the MOVP and the Colony started out as independent operations, both eventually became part of Mr. Shea's rural theatrical empire. He was a hands-on businessman who traveled the vaudeville circuit keeping tabs on his businesses. Most of the details of Mr. Shea's private life are a mystery. We do know, however, that he enjoyed spending time in Marietta, and the MOVP and Colony—or the Putnam and Hippodrome, as he would have called them—were his favorite theatres. The shadowy figure of Mr. Shea has been seen near the MOVP stage, walking down the center aisle and seated in the back row when the house is empty. People have also seen him and felt a simultaneous blast of cold air on the basement stairs.

The second entity is linked to the old projection box, which is now used as the lighting control booth. Actors rehearsing on stage sometimes see a filmy figure moving back and forth in the booth when they are certain it is empty. A movie projectionist, a man who had worked in the theatre since it opened in 1914, suffered a heart attack and died in the booth early in the 1930s. Some old MOVP hands believe he is the one who haunts the booth. Others insist that it is Mr. Shea roaming the building, keeping a watchful eye on things.

The exact number of entities haunting the building and their identities may always be mysteries, but one thing is certain. As long as the Mid-Ohio Valley Players call the old theatre home, veterans will make sure that new recruits are properly introduced to the historic venue. After fledgling actors and actresses learn where the dressing rooms are, how to find their marks on stage and where the costumes are stored, they will be told about Mr. Shea, the projectionist and the stage presence who cannot bear to make a final exit.

THE COLONY

On the other side of Putnam Street stands the Colony, the second of Marietta's surviving historic theatres. Like a fairy tale character, the Colony is awakening from a long, deep sleep. The theatre, which was originally known as the Hippodrome, opened in 1919 with the showing of the silent film *Daddy Long Legs*, starring America's sweetheart, Mary Pickford. Like the MOVP, the Colony also served as a live stage venue. It closed in 1985.

The Colony sat vacant, cold and quiet until a group of local leaders formed the Hippodrome/Colony Historical Theatre Association with the goal of raising enough money to restore it to its former glory. Their tireless efforts are finally paying off. Renovations are underway, and before too long, excited theatregoers will fill the balconies of the majestic old building once again.

The Colony doesn't look like much from Putnam Street, but the exterior is deceptive. In addition to the large stage and seating for twelve hundred people, there are offices, an orchestra pit and several basement dressing rooms, including an enormous one specially designed for chorus girls. Ghost stories and reports of various supernatural shenanigans have swirled around the Colony for years. Most of them were either too vague or too ridiculous to take seriously. But things are changing. As the renovation efforts intensify, reports of peculiar and unexplained incidents in the theatre are on the rise. On two separate occasions, a plumber and an electrician working in the abandoned building saw the apparition of a tall middle-aged man wearing a brown derby. Apparently, the Colony is being visited by the same entity that wanders around the MOVP, the incredibly mobile Mr. Shea.

Workers are not the only ones who have seen Mr. Shea in the Colony. Before the renovation effort was in full swing, the theatre association held community cleanup days from time to time. All types of people would pitch in. During these events several young children asked their parents about the man in the brown hat sitting in the back row. They wanted to know why he wasn't helping. The adults could not see the man, even when the children pointed out exactly where he was and insisted he was right in front of their eyes.

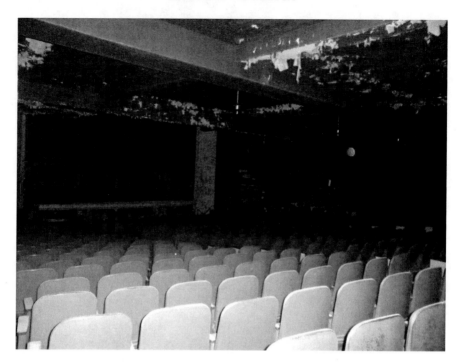

Colony Theatre interior. Note the orb floating above the seats, center right. *Photo by Michael Pingrey.*

Whatever prevented the parents from seeing the ghost seems to be dissipating. In addition to the plumber and electrician, other adults have seen Mr. Shea in the Colony recently. According to these witnesses, he walks the perimeter of the main floor or sits in the first row of the balcony staring at the deserted stage. Mr. Shea sightings are not only becoming more common, but his image is also becoming sharper, steadier and more solid. Perhaps his energy is growing stronger.

The final element linking the MOVP and the Colony is the persistent rumor of a tunnel beneath Putnam Street connecting the two old theatres. Mr. Shea supposedly used the tunnel to spy on the performers and to make sure his employees didn't have their fingers in the till, but he wasn't the only one who used it. When a really popular show came to town, Mr. Shea instructed his staff to sell seats in both theatres. The actors would perform at the Colony first, and when they finished the show, they would run through the tunnel and perform again for the equally enthusiastic but

smaller crowd waiting in the MOVP. There is even a silver screen version of this story that features a perspiring projectionist charging through the tunnel, reels of film unspooling and flapping behind him as he ran. It is not clear why the actors and the projectionist didn't use the front door and simply walk across the street.

The colorful stories about the tunnel contributed to the fact that almost no one believed it actually existed. That all changed in 2006. Workers inspecting the Colony's basement found a bricked-up door under the Putnam Street sidewalk. One of the bricks jutted inward, as if someone had stood on the other side of the door and tried to push it into the Colony's basement. The Marietta Fire Department sent in a team of highly skilled investigators, who unsealed the door and found a tunnel joining the two theatres just as the legend maintained. After checking the tunnel for stability, the fire department resealed the door, an act that has not interfered with Mr. Shea's ability to move back and forth between the two theatres one bit.

Most people who visit the Colony love the old theatre's atmosphere and wish they could stay longer. A few, however, are very uncomfortable. They say the theatre is scary, and even though it is empty, they claim it feels alive. They may be picking up residual energy from a grisly event that occurred deep in the tunnel many years ago.

During the 1920s and '30s, theatrical troupes traveled the country putting on plays and shows. In 1934, such a group was booked into the Colony for a three-night run. After the final performance, an argument erupted between two of the actors. The conflict began when the men, who were standing in the basement outside the chorus girls' dressing room door, discovered they were waiting for the same woman. Insults and accusations quickly escalated into physical violence. As they punched, kicked and swore at each other, the actors drifted into the tunnel. The fight ended when one man managed to pull a jackknife out of his pocket. After stabbing the other actor more than a dozen times, he dropped the knife and ran back into the Colony, leaving his rival to bleed to death on the cold, damp tunnel floor.

The theatrical troupe left town the next morning. The murderer, who was an actor after all, must have come up with a convincing explanation

for the other man's absence. No one in the company reported him missing. And, of course, no one in Marietta had any reason to suspect that anything was wrong; that is, until the victim's body began decomposing.

The Colony, at almost one hundred years old, has been the backdrop for countless dramas large and small, real and imaginary. Thousands of people have passed through its doors, stood on its stage and sat in its plush red seats. Some of them are still present, and there may be more as yet undetected energies waiting in the wings. Intermission is almost over. It's time for the curtain to rise on the Colony's next act.

A PLACE OF HAPPY REVELRY

Today, Ohio Street is an insignificant brick lane running along the banks of the Ohio River, but it wasn't always that way. In the early 1800s, Ohio Street was the most important street in town.

Shortly after Marietta was founded, a commercial district emerged along the Ohio River. The push westward was underway, and at times dozens of boats were lined up, waiting to put into shore. By the time the residents got around to naming the rutted dirt path that paralleled the river Ohio Street, the waterfront was home to warehouses, dry goods stores, shipping interests and boat repair services, all huddled together facing the river that was fueling the new town's explosive growth.

Those who congregated on Ohio Street were a colorful cross section of pioneer times: Indian scouts, wilderness guides, trappers, traders, Native Americans, farmers, river pilots, newly arrived settlers, fortune hunters and dreamers hoping to capitalize on the promise of the uncharted west. The citizens of Marietta were part of the mix, too. They came to Ohio Street to shop for day-to-day necessities, as well as to place orders for luxury goods from Europe and back east. Although the atmosphere was vaguely exotic, the activity on the street was all about business. That was about to change.

A young entrepreneur thought Ohio Street might be a good place to open a tavern. On his first day in business, he ran out of whiskey

before noon. The next day, an even larger number of thirsty customers showed up. In fact, demand was so brisk that he was forced to open a second watering hole in the building next door to handle the crowd. Within a few months, several more taverns had sprung up. All of them served alcohol around the clock. Some offered gambling and distractions of various other sorts, as well. Ohio Street had become the frontier version of the Las Vegas Strip, Bourbon Street and the Yellow Brick Road all rolled into one. A giddy local man described it as "a place of happy revelry."

Not everyone agreed with that assessment. Many Marietta residents were appalled by the change that had come over the riverfront. The crowds wandering Ohio Street were still colorful, but their ranks now included belligerent drunks, pickpockets, con artists and prostitutes. Fistfights and knifings were common. The area eventually became so seedy and dangerous that the merchants who wanted "nice people" to patronize their businesses abandoned Ohio Street en masse. They relocated to Front Street and created the commercial zone that still serves as Marietta's downtown. The spaces that the upstanding businesses vacated were quickly filled by establishments of the other variety.

In the 1880s, the discovery of oil and natural gas in the area sparked an economic and population boom. Fabulous mansions with cupolas, towers, sweeping porches and gingerbread trim rose all over town as the newly rich tried to outdo one another. Dress shops with the latest fashions, grocers, blacksmiths, cabinetmakers and several nice hotels lined Putnam, Second and Front Streets. Everyone benefited from the upturn, including those doing business on Ohio Street. The riverfront had evolved into three solid blocks of beer joints, bordellos and flophouses serving the seemingly endless stream of men from the boats that plied the Ohio. It was still a place of happy revelry, and right in the middle of it all stood La Belle Hotel.

La Belle Hotel wasn't the only brothel on Ohio Street, but it was the largest. The exterior of its three-story brick building was devoid of decoration. The interior, however, was a wonderland of Chinese vases, floral wallpaper, tasseled drapes, velvet chaise lounges, brass beds, potted palms and oriental rugs. La Belle Hotel oozed Victorian excess, and it

A Place of Happy Revelry

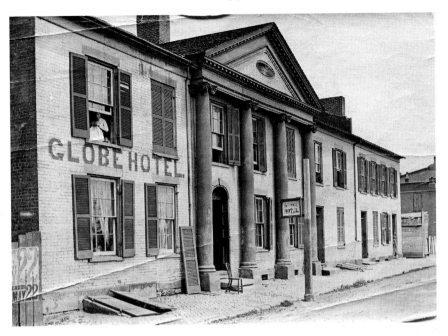

A typical Ohio Street establishment, late 1800s. *Courtesy of the Washington County Public Library.*

exerted a powerful pull on many of Marietta's male residents, including a wealthy oil tycoon.

The tycoon appeared to have it all. Not only had he made a fast fortune speculating in oil, but he was also handsome, an impeccable dresser and had lovely manners. Women gushed and fussed over him, and young men drooled every time his gleaming carriage passed. His spectacular new home on Fifth Street was equipped with every conceivable modern amenity, but late at night he would desert the quiet streets of his respectable, upscale neighborhood and make his way to Ohio Street. A young lady at La Belle Hotel had captured his fancy. He was careful about his visits. He kept a low profile and made sure that his nighttime activities went unnoticed. He had a reputation to protect, after all. He also had a wife and five children.

Everything was fine for a while, but the dalliance soon ripened into obsession. He visited Ohio Street more frequently, became careless and failed to cover his tracks. Word of the affair leaked out. The story rocketed

around Marietta and finally reached his wife, who was devastated, humiliated and beyond consolation. His five children were upset too, even though most of them were too young to fully understand why.

The tycoon could have ended the affair, apologized and attempted to make it up to his family. But he chose to ignore the gossip, his wife's tears, his sulking children and the disapproving glances from Marietta's upper-class ladies and gentlemen. He was determined to continue his midnight visits to the waterfront.

One sultry July night, he was particularly restless. Out-of-town guests and business commitments had kept him from his paramour for more than a week. After dinner, he retired to the parlor of his magnificent house to read. When he was sure everyone was asleep, he extinguished the gas lamps, tiptoed onto the porch and closed the front door softly behind him. But everyone wasn't asleep. His oldest son, who was fifteen years old, was only pretending. As soon as the boy heard the front door close, he went to the basement, got an axe and followed his father down the street.

When they reached Ohio Street, the boy hung back and stayed in the shadows. Music spilled out of the open doors of the taverns, and crowds of people wandered along the riverbank. Most didn't notice the boy with the axe. The few who did didn't give him a second thought. Men working on the boats often carried sledgehammers, saws and axes along the waterfront.

The boy watched his father go into La Belle Hotel. He saw the lights on the second floor come on and then go out. A few minutes later, the boy entered the building, climbed the stairs and stood before the only closed door on the second floor. His heart pounding, he reached out, turned the crystal doorknob and found his father in bed with the prostitute.

It was over in an instant. The boy severed his father's head in a single stroke. Blood soaked the mattress, ran down the walls and dripped from the ceiling. The woman's face was splattered with gore. She was screaming. The boy looked down at his blood-drenched clothing and began screaming too. He dropped the axe, ran down the stairs and tried to lose himself in the crowds and confusion of Ohio Street. It didn't work. Within an hour, he was behind bars, charged with first-degree murder.

No one, not even the expensive Cincinnati attorney the boy's mother hired, disputed the facts of the case. Everyone knew what had happened in the second-floor bedroom. Yet the jury acquitted the young man. Justifiable homicide, they said. Family honor.

After the trial, the boy left town. He was never mentioned in polite society again. But not everyone in Marietta is a member of the social elite, and on moonless nights, when business was slow, the story of the carnage in La Belle Hotel was told in the back rooms and bedrooms of Ohio Street. Reports of strange noises in the hotel stairwell began to circulate, too.

Commercial traffic on the Ohio River dwindled each year as trains and trucks became the preferred means of transporting goods. By the late 1960s, the men who worked on the boats and spent their paychecks in Marietta's waterfront establishments were gone. So were the warehouses, boat repair shops and other businesses. The old buildings that lined Ohio Street were abandoned, empty eyesores. Kids threw rocks through the windows, and rain poured in through the rotten roofs. The few structures that hadn't been condemned needed to be. One by one, they disappeared until the only original building left was La Belle Hotel.

In the 1980s, a local architect became interested in converting the structure into a riverfront restaurant. When his mother found out what he was planning, she was horrified. She could not understand why he wanted to buy "that building." She warned him that his business idea was flawed and that no one in his right mind would consider eating in an old whorehouse.

Luckily for food lovers and fans of historic preservation, the architect ignored his mother. He purchased the building and transformed it into the Levee House Café. The restaurant is located on the first floor. The upper floors of the old bordello were converted into apartments—one on two and a separate unit on three.

As soon as people moved into the apartments, the complaints began, especially with regard to the second-floor unit. Tenants claimed the apartments were haunted. They said candles wouldn't stay lit and that there were cold spots, a classic indicator that ghosts are present. The architect tried to reassure his renters. He explained that the building was one of the oldest in town and that he'd made extensive improvements and planned to make more, but the apartments were always going to

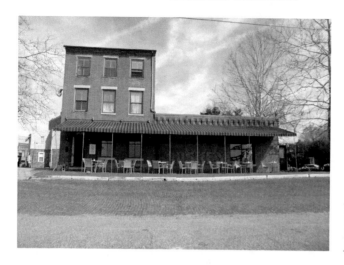

The old La Belle Hotel, now the Levee House Café. *Photo by Michael Pingrey.*

be drafty. Air coming in around the windows was causing the cold spots and blowing out the candles. Several people moved out anyway because something else happens in the old La Belle Hotel, and it has nothing to do with river breezes.

Late at night, the silence in the apartments is regularly broken by the unmistakable sound of someone slowly and deliberately climbing the stairs. When the footsteps reach the second-floor landing, they stop. A few minutes later, the person runs wildly down the stairs and out the front door. This doesn't happen every night. It doesn't even happen every week. But when it does happen, it always unfolds in exactly the same way. A few brave souls have ventured into the stairwell to confront the intruder. No one is ever there. The entire event takes less than five minutes.

This is a residual haunting. The footsteps are the energetic echo of the boy as he follows his father into La Belle Hotel and then flees the ghastly scene. As described in chapter one, energetic impulses from emotionally intense events explode into the atmosphere like the compression waves that follow a bomb blast. The energy remains, replaying over and over, an endlessly repeating tape loop.

Some residuals are short-lived, while others continue for decades. At some point, though, they all dissipate and fade away. The residual haunting at the Levee House is extremely intense. It has been startling people for more than 130 years and shows no signs of abating.

FULL HOUSE

The Lafayette Hotel occupies the most desirable piece of real estate in Marietta overlooking the confluence of the Ohio and Muskingum Rivers. Flowing water is a source of great energy, and the point where two rivers meet is particularly powerful. As it turns out, it is also a place where paranormal activity occurs with surprising regularity.

The original forty-eight settlers who founded Marietta in 1788 landed and came ashore a few yards from what is now the Lafayette's front door. They built rough cabins and surrounded them with a fence of pointed logs. The area came to be known as Picketed Point. By 1804, a mere sixteen years later, the log cabins had been replaced by the mayor's house. It sat on the spot that is now the Lafayette's lobby. According to all accounts, it was the finest house in town. Unfortunately, no descriptions or drawings remain. Several generations came and went, and in 1888 the house was destroyed by a fast-moving fire.

In 1892, a new structure, the Bellevue Hotel, was built on the lot. The Bellevue was an extravagant four-story brick building with an elevator, steam heat, five bathrooms, a barbershop and a bar. It featured a distinctive tower with an onion-shaped dome. Like the mayor's house, the Bellevue met a fiery end. In 1916, flames engulfed the building and gutted the interior.

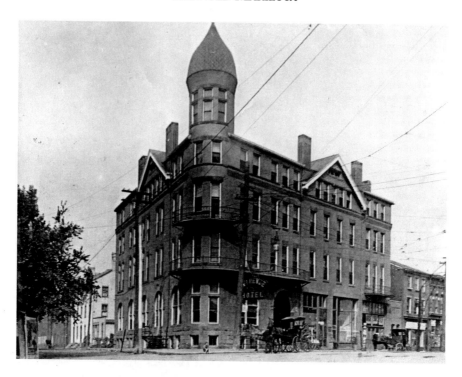

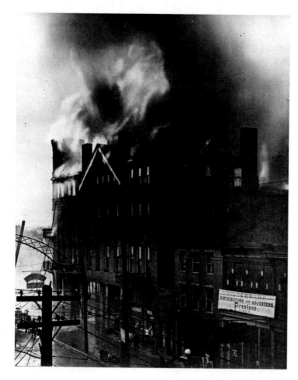

Above: The Bellevue Hotel in the 1890s. *Courtesy of the Washington County Historical Society.*

Left: The Bellevue Hotel engulfed in flames, 1916. *Courtesy of the Washington County Public Library.*

The company that owned the Bellevue rebuilt atop the smoldering ruins. It resurrected many features of the original structure, including the curved corner at Front and Greene Streets and the stone arches above the first-floor windows and doors. Sadly, the onion-domed tower was not part of the new design. In 1918, the hotel reopened amid much fanfare as the Lafayette. Its name commemorates the 1825 visit of the Marquis de Lafayette, French hero of the American Revolutionary War and Marietta's first official tourist.

Checking In

The Lafayette Hotel is a paranormal hot spot. Peculiar things happen in the restaurant and ballrooms, in public restrooms and corridors, in the elevator and kitchen and, most significantly for those who check in for the night, in the guest rooms. A typical report goes like this: I was traveling alone. After I checked in, I went into my room and locked the door behind me. I put my purse on the bed and went into the bathroom. When I came out a few minutes later, my purse was on top of the dresser. I am 100 percent sure I put it on the bed. My purse wasn't open. Nothing was missing. It was just moved. I have no idea how it happened. I know I didn't move it, and I was the only one in the room. The maid did not sneak in, move my purse, sneak back out and lock the door while I was in the bathroom.

Doors open and close on their own; lights, sinks and showers turn themselves off and on; toilets flush in the middle of the night; and guests who go out for the evening often find their dresser and nightstand drawers wide open when they return. One lady came back from a late afternoon stroll to find her shampoo and conditioner bottles dumped in the sink. A young couple's small suitcase was turned upside down while they were in the bar. Another couple spent half an hour searching for the wife's reading glasses, which she had used several times since checking into the room. They went through her purse, emptied their bags, looked under the bed and even checked behind the toilet before giving up in frustration

and going to dinner. When they returned, her glasses were lying in the middle of the floor, in plain sight.

Last August, a married couple came back to their room late. The husband immediately realized that his jeans were not on the bed where he was certain he had left them. This was more than a minor annoyance. Their car keys—the only set they had with them—were in the pocket of his jeans. He and his wife tore the room apart. They looked everywhere, but the jeans were gone. The next morning, the wife found them on the top shelf of the empty closet, wadded up in a ball and stuffed into the corner. She had to stand on a chair to reach them.

A man staying on the fifth floor was in his room alone with the door locked taking a shower. He opened his eyes after rinsing his hair and was shocked to see shadows moving along the outside of the shower curtain. He immediately jerked the curtain open. The bathroom and bedroom beyond were empty.

The shower incident did not surprise the staff. They see unexplained shadows all the time. One of the bartenders went to the basement to get cocktail napkins from the supply room. When she unlocked the door and switched on the overhead light, shadows were flitting all over the floor and stacks of boxes. The bartender called security. A guard came to the basement and stood in the doorway and watched while she went into the room and got the napkins. The security folks at the Lafayette are used to this type of thing.

About three o'clock one morning, a guard was walking down the corridor near the function rooms when he heard the sound of people—lots of people—coming from a closed ballroom. Irritated, he glanced at his watch. No one had bothered to inform him that an overnight event had been scheduled. As he approached the ballroom door, the noise stopped. He opened the door and looked in. The room was empty and dark. The guard closed the door and started down the hall, only to hear the crowd again—buzzing, talking and an occasional laugh rising above the noise. Bewildered, he walked slowly back to the ballroom door. Once again, it grew quiet. He rattled the door without opening it, turned and walked briskly back to the lobby, where there was hot coffee, a radio and a live—if drowsy—desk clerk.

The front desk of the hotel is staffed twenty-four hours a day year-round. At times, the hotel is extremely busy, but it gets quiet late at night, especially during the winter months when there are fewer guests. During these slow times, the desk clerks find it hard to stay awake. Occasionally, they succumb to the temptation to rest their eyes, and that is precisely when the lobby elevator acts up. Dozing clerks are routinely startled by a loud "Ding!" followed by the whoosh of the elevator doors closing. They watch the floor indicator lights as the car travels to the sixth floor with no intermediate stops. The sixth floor is the roof. It is not possible to call the elevator from the roof, and there is no floor button in the car that sends the elevator to six. A security key is needed, and only the general manager and chief engineer have copies. Nevertheless, clerks and night auditors report that the elevator makes frequent midnight visits to the roof, where it stays for a few minutes before returning to the lobby. Empty.

New employees find the elevator's antics disturbing. Those who have worked at the hotel for a while don't give it much thought. They attribute the activity—as well as the unexplained blasts of cold air, the missing cups of coffee, the disappearing and reappearing files and the exploding light bulbs—to the ghost of the property's former owner and manager, Mr. Hoag.

THE QUINTESSENTIAL MANAGER

The Hoag family bought and moved into the Lafayette Hotel in 1924, when the man we call Mr. Hoag was a teenager. Over the next several years, he learned the ins and outs of the hotel business by watching and helping his father manage the property. The young man eventually became the proud owner and manager of Marietta's finest hotel.

Mr. Hoag was an astute businessman and an excellent hotelier. Under his guidance, the Lafayette blossomed into an elegant hotel and a very successful operation. Mr. Hoag oversaw all the details, frequently walking the halls in the middle of the night to make sure everything was in order. If he discovered a burned-out light bulb, he called maintenance to fix

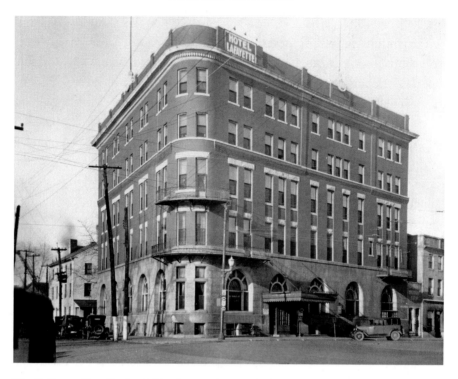

The Lafayette Hotel in the 1920s. *Courtesy of the Washington County Historical Society.*

it. If that meant rousting someone out of a warm bed at two o'clock in the morning, so be it. The staff did not resent Mr. Hoag's demands, micromanagement and obsessive behavior. They respected him. Plus, they shared his pride in the hotel and his desire to give the Lafayette's guests a first-class experience. The fact that he was a happy, friendly, eccentric individual didn't hurt either.

Mr. Hoag enjoyed spending time in the hotel bar, where he held court, entertained his friends and played practical jokes. He slipped whoopee cushions onto the bar stools when patrons went to use the restrooms and had the bartenders serve cocktails in dribble glasses. His favorite prank was filling people's closed umbrellas with Corn Flakes when they weren't looking.

Mr. Hoag retired and sold the property in 1973. He died eight years later. There was nothing sinister or odd about his passing. He lived a charmed life, and his time had simply come. He did not die in the hotel.

Several other people, however, have. Guests die in hotels every day. The most common cause is heart attacks. The strange thing about the deaths in the Lafayette is not that they occurred; it's where they occurred. Everyone who has passed away in the hotel since 1918 has died on the third floor.

The third floor is the most paranormally active area in the Lafayette, and the staff attributes the activity to Mr. Hoag. He and his family lived on the third floor. Maids, security guards, porters and engineers avoid that floor if possible. They report feeling uncomfortable, as if they are being watched. Some have heard footsteps in empty hallways and have been touched by invisible hands. Others have seen flashes of light and odd reflections in windows and mirrors. Hotel management received so many employee complaints about weird images in a large mirror on the third floor that they took it down and rehung it in the lobby.

It's not only hotel employees who think Mr. Hoag wanders the halls. Many local people who knew him believe he is still in his beloved hotel. They think he plays practical jokes on guests and staff, just as he did in life.

Last autumn, a group of motorcycle enthusiasts checked into the Lafayette for the weekend. They took the Ghost Trek walking tour of downtown on Friday night. One of the bikers could barely contain himself during the Lafayette visit. He laughed and joked about Mr. Hoag's ghost the entire time. When Saturday night's tour arrived at the hotel, most of the motorcycle group was waiting in the lobby. They wanted to report what had happened overnight.

After a rollicking couple of hours in the bar, they had agreed to meet at 7:30 a.m. on Saturday and headed off to bed. The man who had made fun of Mr. Hoag's ghost was in a single, sleeping alone. He got into bed about midnight. Before he turned off the light, he double-checked his alarm, which he had set for 7:00 a.m. He had a hard time waking up the next morning. It was still dark, and he was sleepy. But he knew his friends were waiting, so he got up, showered and went downstairs. He stood in the empty lobby for several minutes before checking his watch. It was 3:30 a.m. Four hours later, when he told his friends what had happened, they suggested he was responsible. You were tipsy, they said, you set the clock to the wrong time. He shook his head. He is convinced that Mr.

Hoag's spirit paid him a midnight visit and reset his alarm to pay him back for the jokes.

Some guest experiences are more meaningful. A Ghost Trek participant sent me the following e-mail:

We took your tour and really enjoyed it. However, I am a little skeptical, more of a prove it, a scientific sort of guy. My wife and I were in Marietta to celebrate our 31st wedding anniversary last weekend. Each year we would pick someplace and just go there. Over the years as we grew older it seemed the "party" was over. We are now in our 60s and no longer drink or roam the streets to the wee hours. Seemed the magic was fading.

We stayed in the Lafayette. On the morning of check out, we grabbed our bags and left. When we got home we found a letter tucked away in the baggage titled "Some Thoughts for the Girls on Our 52nd Anniversary." To top it off we also found the funeral program for Walter Davidson, dated Feb. 10, 1997, in our luggage. The poem on the program and the essay "In Loving Memory of My Husband" touched us both so much it renewed the magic of 31 years of being together.

Thank you to the ghosts of Marietta for slipping these into our luggage when we were not looking. Neither of us have any idea how they got there but the message was clear. The odds of these things hitting my thoughts and feelings have to be a billion to one. Let alone how they got in our zipped up luggage!

"Some Thoughts for the Girls on Our 52nd Anniversary" is a single-page document prepared on an old-fashioned typewriter. It is not addressed to anyone, nor is it signed. It is someone's memories of Parkersburg, West Virginia (located about fifteen miles from Marietta), in the 1920s and '30s. The writer reminisces about various businesses now long gone, how much things used to cost, etc. The Walter Davidson funeral program includes the deceased's picture and obituary. Mr. Davidson was a local attorney. The source of the documents remains a mystery.

Another gentleman described a pleasant, but bizarre experience he had in the hotel. It was Sunday night, about 11:30 p.m.. He and his

lady friend were on the balcony of their room enjoying the moonlight sparkling on the Ohio River. The man called the front desk and asked that a bottle of wine be sent up. The clerk said that both room service and the bar were closed for the night. The man said he'd gladly pay someone to go to a store and bring a bottle back. The clerk said there wasn't anyone available. The guest, who had been staying in the Lafayette off and on for years, lost his temper. "If Mr. Hoag were around," he shouted at the desk clerk, "he'd find a way to get a bottle of wine delivered!" He slammed down the phone and returned to his disappointed friend on the balcony.

About half an hour later, someone knocked on the door. When the man answered, the corridor was empty, but a room service tray with a bottle of wine, a corkscrew and two glasses was sitting on the floor. The man said it was excellent wine, and he and his friend thoroughly enjoyed it.

The next morning he called the desk to apologize for getting angry and to thank the staff for sending the wine. The clerk he had spoken to the night before was still on duty. She insisted she had not sent the wine up and didn't know who had. The guest assumed it was a simple lack of communication between employees but was surprised when he examined his bill at check out. "It was an expensive bottle of wine," he said. "There was no room service charge, nothing from the bar or restaurant either. I remember Mr. Hoag. He was the consummate host and never let anyone's glass get empty. I know it sounds crazy, but I think he made that delivery."

The Gun Room

Mr. Hoag had distinctive taste when it came to decorating. He personally selected most of the hotel furniture, carpeting, drapes and accessories, achieving a look best described as Rat Pack–era Las Vegas meets Victorian riverboat. His decorating style reached its pinnacle in the Gun Room Restaurant, which features white gingerbread woodwork and antique long rifles mounted on burgundy wallpaper. Mr. Hoag loved the Gun Room. He ate most of his meals there and often conducted

impromptu business meetings at his favorite table in the corner. He was fond of lingering over coffee or cocktails while the restaurant staff worked around him. According to several waitresses, he has been sitting at this special table much longer than anyone expected.

A pleasant young woman was hired for the breakfast shift a few years ago. She arrived for her first day of work early, at 5:00 a.m. The restaurant was dark except for the small lamp illuminating the hostess's station. It took a few moments for her to realize that an older man was sitting at the corner table near the back wall. She walked over at once and asked if he was ready to order. He didn't respond. She went to the kitchen, got a pot of coffee and returned. The man was gone. The next day, the same thing happened: the same man was in the same seat at the same table. He didn't respond when spoken to and disappeared while she was getting the coffee. This time, the new waitress told the people in the kitchen what had happened. "Oh yeah," the head cook said. "That's the owner. He has to have that table. He died in 1981."

The young woman said that Mr. Hoag looked like a normal older man. He wasn't transparent—no trailing tendrils of ectoplasm, nothing unusual at all. That's why she tried to wait on him. The story was over the top, but the former waitress seemed reliable, so I decided to add the sighting to Ghost Trek and let people make up their own minds. A few weeks later, a quiet middle-aged couple taking the tour said that the waitress was their daughter and the story was true.

The plot thickened, as they say, later that summer when a second waitress surfaced. Like the first young woman, she was hired for the breakfast shift at the Gun Room. She encountered Mr. Hoag her third day on the job. She was the first to arrive that morning. The restaurant was completely dark. When she turned on the small lamp at the hostess station, she saw an older man sitting at the corner table near the back wall. "I'm sorry, sir," she said. "We're not open yet." She flipped on the overhead lights and turned back to the customer, but he was gone. "He must have evaporated," she said. "There is no way he could have left the restaurant without walking past me. No way at all."

The latest sighting involves several people, all young women working in the Gun Room. The story has its roots in the 1960s with the building

of Interstate 77. When local leaders discovered that the proposed route for the new Interstate 77 missed Marietta by miles, Mr. Hoag got busy. He spoke to dozens of people connected with the Interstate Highway system and even traveled to Washington and lobbied Congress to get the route changed. He succeeded, and Interstate 77 was built through the eastern edge of town. If Mr. Hoag had failed and Marietta had been bypassed as originally planned, the town's economy would have been severely, if not fatally, damaged. Mr. Hoag's efforts earned him the town's everlasting gratitude and the nickname "Mr. Marietta." The *Marietta Times* recently ran a story about the history of Interstate 77 that described Mr. Hoag's role and included his picture. The article caused quite a stir in the Gun Room.

"We couldn't believe it," one of the waitresses said. "We looked at that picture over and over and we all agree. He's definitely the guy who sneaks into the restaurant before the breakfast shift!"

Several of Marietta's service clubs hold their meetings in the Gun Room. Last Halloween, I addressed one of the groups and told them about the paranormal activity in the hotel. Some of them thought the reports of Mr. Hoag sightings were hilarious. They started making jokes about him. I mentioned that others who made light of the stories often found themselves on the receiving end of what appear to be supernatural pranks. This pushed them completely over the edge. As the meeting ended, one of the men discovered that his cellphone was missing. Things got very quiet when a woman sitting at another table found it in the pocket of her sweater.

The kitchen is the scene of disruptions, too. Knives, vegetable peelers, spoons, sponges and garlic presses disappear, only to turn up later in other parts of the hotel. A man who recently retired from the kitchen said that the activity always intensified prior to the arrival of a River Queen. Until recently, the *Delta Queen, Mississippi Queen* and other fabulous passenger boats traveling up and down the Ohio River called on Marietta. The kitchen worker said that utensils would start disappearing about three days before a boat was due, and the incidents would increase daily. Once the boat arrived, everything would calm down. "We all assumed it was Mr. Hoag," he explained. "He always got jumpy before a boat came in."

THE LADIES RETIRING ROOM

Unexplained activity of a different sort occurs in the basement, a maze of winding corridors, conference space and private dining rooms. A narrow curving staircase leads down from the lobby. At the foot of the stairs is the Ladies Retiring Room, which is Lafayette-speak for the ladies restroom. Hotel employees have seen an apparition of a little boy standing in front of the restroom door. He is about five years old. He doesn't do anything. He just stands there.

The boy's image is fleeting. No one has seen him clearly enough to describe what color hair he has, what he's wearing or any other details about his appearance. He is more of an impression, a will-o'-the-wisp. There is no story about the boy, nothing to explain who he is or why he is standing at the bottom of the stairs.

The Ladies Retiring Room has mysteries of its own. There is a presence in the restroom. There is nothing voyeuristic or threatening about it. It is female. Like the little boy in the hall, she is just there. There is no story about her either. Her identity and reason for being in the basement are unknown. Some people feel the woman is the boy's mother. They think the child is waiting for her outside the restroom door. That's plausible, but there are other possibilities.

The fact that there is no story or legend about either entity, nothing that explains why a woman and child would be in the basement, may be an important clue. They may be from a time that precedes the Lafayette. Maybe they are from the days of the Bellevue Hotel or the mayor's house, or even earlier. The physical space they occupy may have nothing to do with the Ladies Retiring Room. They could be standing together in an open field for all we know.

The Ghost Trek tour visits the Ladies Retiring Room. Many participants have a peculiar experience while there. A feeling comes over people—usually women—after being in the room for a few minutes. They feel pressure on their chests. They need to inhale deeply to get full breaths. It's not painful, but the sensation can be disturbing. Most people are anxious to leave the Ladies Retiring Room. The minute they step into the corridor, the pressure disappears.

I have experienced the feeling of pressure many times and have often speculated about its cause during the tour. One evening, a woman stepped forward and said, "I feel it, too, and I know what it is. The Bellevue Hotel and the mayor's house burned down. We're picking up the fire and smoke. It's affecting our lungs."

The stories and reports about incidents in the Lafayette go on and on. We've barely scratched the surface. New claims of mysterious noises, ghost sightings, paranormal disruptions and supernatural activity surface each month. The unexplained and unexpected are part of the hotel's fabric. Guests might be sharing their rooms with unseen entities, front desk people are never sure what they'll see in the middle of the night and local folks who drop in for a beer wonder what they might encounter in the restrooms. It's what keeps us coming back for more. And there is no doubt that the Lafayette will continue to be one of the hottest spots in the paranormal zone known as Marietta for many, many years to come.

A TRIO OF FRONT STREET HAUNTINGS

There are many strange stories along Front Street. Some of theoddest hover over the 200 block.

GOING DOWN?

In the early 1900s, 258 Front Street became the center of attention, which was exactly what the building's new owner wanted. Enamored with gadgets, machines and everything the new century had to offer, he announced that he was going to add an elevator to the back of his building. Marietta had a few elevators, but the technology was considered cutting-edge. To the many who refused to set foot in them, elevators were nothing but deathtraps. Best to use the stairs.

That summer, dropping by 258 Front to check on the progress of the installation became a favorite activity for many in town, especially as the project neared completion. One afternoon, the owner looked out the back window and noticed more people than usual milling around the construction site. It was a lovely day, and he decided to educate them on the finer points of elevator operation. He strutted around the site

pointing out various features and then positioned himself in front of the shaft, cleared his throat and waited. When he had everyone's attention, he removed his hat with a great flourish, leaned into the opening and twisted so that he was facing up the shaft. At that very moment, the cable holding the newly installed car—which was on the roof—snapped. The man's head was severed as cleanly as if he'd been guillotined. Demand for elevator installations in Marietta lagged behind the rest of the country for a long time, but people eventually forgot about the accident.

Over the years, people working for the parade of businesses that trooped through 258 Front shared the same unnerving experience. When working late, after traffic died down and the town fell silent, employees heard things—whooshing noises and creaking sounds, like the pulleys on an old-fashioned elevator. A few were convinced the building was haunted, but no one ever reported spirit activity. There were no ghost sightings or cold spots, no objects disappearing or moving on their own, just the peculiar noises.

This is yet another of Marietta's many residual hauntings. The strange sounds are a replay of the elevator falling. Even though they are dead, the

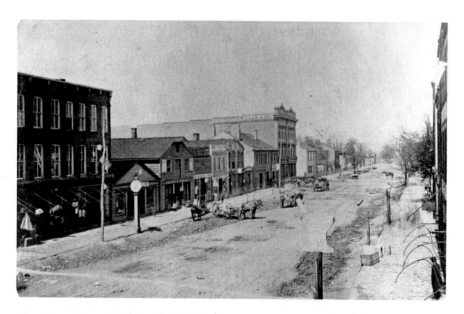

Front Street, circa 1860. *Courtesy of the Washington County Historical Society.*

people who witnessed the decapitation one hundred years ago are part of the phenomenon. The energetic residue of the intense horror they all felt at the same instant fuels this ongoing episode.

There is one interesting and significant difference between this case and the residual at the Levee House. The building the Levee House occupies has been updated since its La Belle Hotel days, but the basic structure hasn't changed much. This is not true at 258 Front. The elevator and shaft were removed decades ago, and a fire in 2003 destroyed everything else, except for a portion of the front wall. A brand-new structure incorporating what was left of the 1900-era brick façade was constructed where the old building stood. Nothing that had contact with the elevator or shaft remains. There is no physical connection. Yet the residual continues. The energy from this terrible accident has become part of the environment, clinging to a general location rather than to a specific structure.

A Muted Palette

Sugden Books has been in business for more than eighty years. For the last decade, the shop has been located at 282 Front Street.

One evening, the store's owner attended a party where she ran into an old classmate whose mother had recently passed away. Her friend and his sisters were in town to clean out the family home, and just that afternoon they'd discovered fifty paintings by Marietta artist James Weber in the basement.

James Weber was born in 1888 to a family of grocers. Everyone assumed that when James grew up, he would work in the family business. But the boy wasn't sure. He thought he might want to be an artist. That did not sit well with his parents, who had worked so hard to build a profitable business to pass on to their son. They informed James in no uncertain terms that his future involved tomatoes, onions and bread, not canvases, brushes and paint.

As he became a teenager, James grew more and more certain that the grocery business was not for him. He was an intense and sensitive young

man who suffered from what the Victorians called melancholy. Between bouts of depression over what he saw as his dismal future, he begged his parents to allow him to attend art school. They finally surrendered and agreed to send him to one in Cincinnati.

Art school worked out very well for James. He met people who shared his interests, and his teachers helped him develop technically and artistically. A postimpressionist painter, he won a number of student awards and prizes. His next logical step was to travel to Paris or New York to continue his studies. As he was weighing his options, he received news that his father had been seriously injured. The last line of the telegram was simple and to the point: "Come home." James Weber understood that his return to Marietta would not be temporary.

Moving back to the place he had worked so hard to escape was the last thing in the world he wanted to do, but James did as he was asked. He spent the rest of his life selling groceries. He painted when he could and continued to struggle with his melancholy. As he watched others with less talent succeed in the art world, James became bitter. Near the end of his life, he told anyone who would listen that as soon as he died he wanted all his paintings burned. But James Weber's last wishes remained as unfulfilled as the dreams of his youth, as the people cleaning out their deceased mother's basement had just discovered.

The owner of Sugden Books felt sure that people would like to see the paintings, and her former classmate agreed. So they hung the fifty canvases in the bookstore's second-floor mezzanine, a sunny spot often used for art shows. The night before the show opened, the owner placed a table at the foot of the mezzanine stairs. She put a small self-portrait of the artist on the table, as well as cards about James Weber's art and life. The last thing she did before leaving for the evening was to clear her desk.

When she arrived in the morning, the table was knocked over, the cards were scattered around the shop and James Weber's self-portrait was face down on the floor. In the center of her otherwise empty desk was a typed, stapled report, open to a certain page. Completely bewildered, she picked it up. The report was a history of 282 Front Street, including the names of all the previous occupants. The realtor who'd sold her the

building ten years earlier had prepared it. The owner wasn't sure where the report had been for the last decade, but she had a feeling she knew who had put it on her desk. The page it was opened to said that in 1932 the mezzanine of her building had been James Weber's art studio.

Talk About Us

Number 220 Front Street has housed dozens of establishments in its one-hundred-plus-year history, including a cigar factory, a hardware store, retail shops, offices and apartments. "The Dish Ran Away with the Spoon," which appears above the arched entrance, was the name of one of the many gift shops that have come and gone.

The building's most notorious owner and occupant was a man named Pete, who ran a popular restaurant and lounge on the premises in the 1950s. Each evening, as the dinner rush ended, Pete retreated to his office on the third floor. After a few drinks, he climbed the narrow spiral staircase to the small penthouse on top of the building, opened the door and stepped out onto his favorite place—the roof. He loved to sit on the front edge of the building, his legs dangling above the tops of the third-floor windows, and drink the night away.

Pete was an independent sort of character and sometimes left town for a few days without telling anyone where he was going. But when he had been gone for a week and had missed the annual Fourth of July blowout at his restaurant, his wife got worried and called the police. Officers found his corpse sprawled on the roof in a sea of empty liquor bottles. Luckily for Front Street pedestrians, Pete had fallen backward rather than over the edge of the building when he lost consciousness. About two weeks after he was laid to rest, strange things began happening in his building, strange things that continue to this day.

The ground floor is a gift shop and framing gallery. Small items are constantly moved around, and the staff finds framed prints that were hanging securely when they went home lying facedown on the floor in the morning. Books refuse to stay shelved on a small bookcase in the back

room. The bookcase is level. The owners checked that. They also moved it to a couple of different locations to see if that would help. It didn't. It's as if someone passes through the shop in the middle of the night, rearranges the knickknacks, takes down the pictures and knocks the books off the shelves. Whoever or whatever is causing these disruptions also seems to have an issue with timepieces. The owners have stopped trying to keep clocks in the shop synchronized.

The second and third floors are condos. A spiral staircase still leads from the third-floor unit to the roof. A few years ago, a woman living on the third floor saw a man in an old-fashioned suit on the spiral stairs several times. Apparently, dogs and cats see him, too. Animals do not like living in the condos. They're nervous, can't relax and have a hard time sleeping. And even though the entire building was recently rewired, lights flicker and ceiling fans turn themselves off and on. The oddest anomaly, however, has to do with the door in the penthouse, the one that opens onto the roof. No matter how often it's closed, every time anyone goes to check, the door is standing open.

The building's exterior still bears faded and peeling fragments of advertising from Pete's day. "Talk About Us," the back wall of the penthouse whispers. Don't worry, Pete. We are.

SEE US FOR YOUR EMBALMING NEEDS

Funerals were low-key affairs in early America. People were buried within a day or two of their passing with very little fanfare. When someone died, the family summoned the undertaker, who came to the home and provided a coffin. That was his sole function. The image of undertakers as gravediggers or vaguely sinister characters in top hats hovering in the background at funerals comes from movies, not reality. Most of them were carpenters, cabinetmakers or men employed by furniture companies. A typical advertisement from the early 1800s might read as follows: "ABC Furniture offers the finest in wood tables, picture frames, coffins and beds."

Marietta was a lucrative market for undertakers. The Triangle Company, located on Front Street, specialized in "musical instruments, furniture and mortuary services," and the Wieser Company on Putnam Street reminded its potential customers that it offered "furniture of all styles in leading grades," as well as "everything necessary in the undertaking line."

The link between the furniture and undertaking businesses started to dissolve with the introduction of embalming, a process that preserves the body after death. No one was embalmed in early America. It simply was not part of the culture. But that changed during the Civil

War. Many young men were killed in battles far from home. The army began embalming them so their corpses wouldn't deteriorate before they reached their grieving families. As the war dragged on and the casualties mounted, the number of people exposed to the benefits of embalming grew. Widespread public acceptance followed the assassination of Abraham Lincoln. The president died on April 15, 1865. He was not buried until May 4.

Lincoln's embalmed body lay in an open casket in Washington for six days before being placed aboard his funeral train. The train worked its way slowly toward Springfield, Illinois, passing through 180 cities in seven states. At each of its dozens of stops, a grand funeral, with an open coffin and public viewing, was held. To make sure the body was presentable to the hundreds of thousands of people who waited for hours to pay their respects, Lincoln was re-embalmed at each stop. According to some estimates, one out of four Americans viewed his body. His well-preserved face made an impression on all who saw it.

As more and more people began requesting embalming services, undertakers found themselves at a business crossroads. Should they learn to embalm corpses or was it better to stay with what they knew— furniture making. No doubt, many struggled with the decision. It's not clear what the owners of the Triangle Company decided, but the answer was obvious to the Wiesers. They decided to add an embalming parlor to their furniture store at 212 Putnam Street.

If they had started from scratch at a new location, they never would have chosen the third floor for their embalming operation. All the equipment—gurneys, embalming tables, glass bottles and tubes, fluids and chemicals, not to mention the coffins and the bodies—had to travel up and down in the newly installed elevator. But that was the way it had to be. The ground floor of the building was the furniture showroom and the second floor housed the cabinetmakers, some of whom would soon be reassigned to the new department on three.

Imagine a group of men working on picture frames and kitchen chairs. It's a Saturday afternoon in 1871, almost quitting time. The company's owner walks into the workshop. The hammers and saws fall silent. The owner explains that the company is expanding and that several of the

carpenters have been selected to learn an exciting new skill: embalming. As he elaborates on what it all means, a young man rushes out of the room and becomes ill.

The Wieser Company ran a successful embalming operation for many years before abandoning it to focus exclusively on furniture. The firm evolved into Wieser and Cawley Furniture, still in business and one of Marietta's nicest stores. The building at 212 Putnam Street underwent changes over the years, too. In 1901, a new façade bearing the name Wieser was affixed to the front of the structure, and for reasons that are not clear, all the upper-story windows were sealed in stone. Interior changes have been minimal.

The Wieser
Building. *Photo by*
Michael Pingrey.

Until a few years ago, the Wieser Building housed a bridal boutique. As in the furniture company days, the first floor functioned as a showroom and retail space. The owner's office was on two. She had access to the third floor but didn't use it for anything. It remained empty. It did not, however, remain quiet.

Each evening after she closed the shop, the owner went to her second-floor office to make calls, do paperwork, work on billing, etc. Her concentration was frequently broken by noises from the third floor. Since she was the only tenant in the building, this was frightening, to say the least. Nevertheless, she would go to the third floor and check. There was never anyone there—nothing to explain the heavy footsteps she heard pacing back and forth or the screech of heavy furniture being dragged across the floor, and certainly nothing to explain the occasional sound of glass shattering.

The owner never got used to the noises, but she did find a way to neutralize the unexplained racket. She bought a radio, turned the volume up and tried to keep her mind on her work. When she left the building each night, she rode the service elevator to the parking lot in back, the same elevator the Wieser Company had used to transport corpses. The old elevator has etched-glass doors. The owner of the bridal shop—who has since found a new location—refused to gaze at her reflection in the doors as she waited for the elevator car to arrive. She was sure something would be looking over her shoulder.

The mysterious sounds in the Wieser Building are residual vibrations from the embalming parlor. The carpenters who were drafted to work with the dead may have been deeply disturbed by their new assignments. Some were probably afraid of the corpses and believed that what they were doing to them was ghoulish and immoral. Measuring dead people for caskets is one thing. Draining and replacing their body fluids is an entirely different matter. To top it off, they were trainees trying to learn difficult skills. In the beginning especially, they made mistakes, mistakes that haunted some of them for the rest of their lives. And now they're haunting us.

DYNAMIC PERSONALITIES, ACTIVE BUILDINGS

Nahum Ward and Betsey Mills each made significant and lasting contributions to the quality of life in Marietta. Although they lived in different centuries, they had several things in common. They were both crusading social reformers, they used their personal fortunes to benefit others and each was associated with a particular downtown building. Today, those buildings are paranormal hot zones.

THE UNITARIAN CHURCH

People accept stories of ghosts lurking in cemeteries without batting an eye. Many, however, are surprised to hear about haunted churches. They shouldn't be. Spirits are drawn to places with strong positive energy. Cathedrals, churches, monasteries and convents are often the sites of ghostly activity.

In a town blessed with dozens of old buildings and interesting legends, the Unitarian church, located on the corner of Third and Putnam Streets, is in a category all its own. Its history is intertwined with the life story of the man who founded it, Nahum Ward.

Ward moved to Marietta from New England in 1811 and soon became one of the town's most prominent citizens. A wealthy and shrewd land speculator, he served as mayor from 1833 to 1836. His large and elegant home was the setting for sophisticated dinner parties, balls and formal teas. The Marquis de Lafayette stayed with Nahum Ward and his wife in 1825, and a few years later the Wards hosted John Quincy Adams.

But Ward was more than a rich socialite and politician. He was deeply interested in spiritual matters. In January 1855, he placed a notice in the newspaper inviting people to join him in forming a new church, a Marietta branch of the Unitarian Society. Several heeded his call. Ward covered 100 percent of the church's construction costs, contributions that meant he had the final say on how the building would look. Several years earlier, while visiting England, he had been mesmerized by a Gothic cathedral. He contacted John M. Slocomb, architect of the Castle and the Anchorage, and asked if he could replicate the English design. The architect assured him that he could, and work began in July 1855.

A rather mystical man, Nahum Ward wanted his church to be linked to the ancient past. About two thousand years before his time, an enigmatic people known as the Hopewell lived in the Ohio Valley. They built a massive complex of earthworks on the site that later became downtown Marietta. In addition to mounds and pyramids, the Hopewell constructed a 150-foot-wide walled passageway that ran from the banks of the Muskingum River to an elevated square near present-day Third Street. Its earthen walls were 680 feet long, and they ranged from 10 to 30 feet high. The walls stood until the 1840s, when a local businessman leveled them and transformed the clay they contained into bricks. Nahum Ward purchased those bricks and incorporated them into the walls of his church.

The bricks are not the building's only unusual element. According to a persistent legend, the elegant curving staircase that leads to the balcony was built by a slave. When the slave's owner saw the beautiful masterpiece he had created, he freed the man on the spot. Unfortunately, both the slave's and owner's names were forgotten long ago.

It's no mystery who produced the large painting on the wall behind the pulpit. It is the work of local portrait artist Sala Bosworth. When

Nahum Ward's Unitarian church. *Photo by Michael Pingrey.*

Christ Weeping over Jerusalem was unveiled, many commented on the uncanny resemblance the painted image of Simon Peter bore to Nahum Ward. Ward was pleased that his face would permanently gaze at the congregation, but he was interested in reaching a broader audience. He wanted to make sure that non-churchgoers knew who was responsible for the building, too. So he hired a mason to carve his name in huge letters into a block of stone and attach it to the side of the church. It's still there.

The church was completed in 1857. The morning the first service was held should have been the happiest day of Ward's life, but trouble was brewing. A group of Universalists had just arrived in town with the intention of forming a rival church. Ward was livid, and with each passing Sunday, as his hoped-for crowds of new church members failed to materialize, he became angrier. The fact that fewer than a dozen people joined the Universalists did not mollify him. He hurled insults at their leaders whenever possible, lay awake in bed stewing and hatched endless plots to block the Universalists' plans.

Nahum Ward died in the summer of 1860. Hundreds turned out for his grand funeral. It was warm and sunny when the mourners entered the Unitarian church, but by the time the service ended, the sky was

dark and threatening. Gusts of wind buffeted Nahum Ward's friends and family as they lined Third Street waiting for his body to emerge. As his coffin was hoisted onto the horse-drawn hearse for the short trip to Mound Cemetery, a single deafening clap of thunder echoed through town. It started to rain, and it poured for twenty straight hours, long enough to cause minor flooding. The Universalists' headquarters was the only place in town that suffered water damage. All of their papers and books were destroyed.

Before his demise, Nahum Ward carefully considered several potential grave sites in Mound Cemetery. He chose a plot atop a gentle rise overlooking the city and spent many happy hours selecting an appropriately grand yet tasteful monument: a white marble obelisk with a carved likeness of his face ringed by a wreath of flowers. Placing the obelisk on the rise would make it seem even taller than it actually was.

Ward's plan to have one of the finest monuments in the cemetery would have worked if someone hadn't planted a holly bush on his grave. Its branches completely engulf the obelisk. Most cemetery visitors walk past his grave without even noticing it. However, if you stand in just the right spot, you can see his stone eyes peering out through the veil of prickly green leaves.

In 1869, Marietta's Unitarians and Universalists joined together, predating the nationwide merger of the two groups by ninety-two years. The church on the corner of Third and Putnam Streets is still in use and welcomes visitors interested in seeing Sala Bosworth's painting, as well as the marvelous carved staircase. But the story doesn't end there. The church is haunted.

No one ever experiences anything while services or social events are underway. It's only later, when the church is empty and people are alone, that things happen. The majority of reports come from church members who volunteer to clean the premises. As they work in the quiet old building, they are often startled by the sound of a woman singing in the balcony. She sings a few notes and then stops. No one ever sees her, nor do they know who she is or why she is there.

Others have had unsettling encounters in the balcony. Like those who hear the singer, it is always a solitary experience. People sometimes return

to the church after services, musical programs or other events have ended. They climb the beautiful winding staircase to retrieve umbrellas, scarves or gloves. When they reach the balcony, they report feeling uneasy, as if they are not alone. Some have felt the temperature drop. Others are sure they were being watched. Everyone has the overwhelming urge to leave at once. The singing spirit could be the source of this negative energy. It's also possible that someone, or something, else shares the balcony with her.

The Girls' Monday Club

In 1911, wealthy socialite Betsey Mills and a group of her community-minded friends founded the Girls' Monday Club. Their goal was to promote "all-round development in the ambitious, self-respecting girl." The club offered a wide variety of practical classes, such as sewing and cooking, as well as wholesome social activities. In the beginning, classes and events were held in people's homes, but the organization quickly attracted a large following, and permanent space was needed. Betsey Mills purchased her childhood home, a frame house on the corner of Fourth and Putnam Streets, to serve as club headquarters, and a few years later she bought the house next door and donated it as well.

When Betsey Mills died in 1920, her bereaved husband financed a significant expansion of the club's facilities as a memorial to his wife. Curious townspeople watched as the two frame houses disappeared behind a brick Georgian façade and a three-story addition with classrooms, offices, an indoor heated swimming pool and a full gymnasium rose behind them. When the project was completed, the board of the Girls' Monday Club voted unanimously to rename the organization the Betsey Mills Club.

The Betsey, as the club is fondly known, still occupies the big brick complex on the corner of Fourth and Putnam Streets. People of all ages enjoy the pool; dances, fashion shows, dog obedience classes, aerobics, pickup basketball games and craft shows are held in the gym; and the staff and day-care children make good use of the offices and classrooms.

The Betsey Mills Club. *Photo by Michael Pingrey.*

When people learn that the Betsey Mills Club is haunted, most assume the supernatural disruptions occur in the older parts of the building, in the two old houses that were incorporated in the 1920s or maybe in the dormitory-style women's residence. Hundreds of ladies, some under great emotional stress, have paced the long hallway and spent sleepless nights in the Betsey's small bedrooms. But neither of these areas is where the activity happens. The paranormal events occur in the newer part of the building, where the pool, gym, offices, classrooms and locker rooms are located.

Employees working in that portion of the club spend a lot of time searching for missing objects. Items disappear and then reappear in new locations, sometimes weeks later, only to disappear again. Brooms and dustpans frequently travel from the gym to a closet in the ladies' locker room, and teacups make their own way to a crawl space beneath the stage. Missing and rearranged objects are so common that the staff shrugs off the incidents by saying, "Betsey moved them," a comment that always elicits nervous laughter, especially from new hires.

The oddest thing about the paranormal events at the Betsey is that many of them include a visual component. Recently, the day-care students were having lunch in the gym. A teacher's aide was stationed near the door to the stairwell, which leads to the pool one floor below

and to the offices one floor above. As she leaned against the doorjamb and watched the children eat, she caught movement in the stairwell. The aide whirled around just in time to see a man rounding the corner of the upstairs landing. She glanced back at the children. A four-year-old boy sitting near the door was pointing at the stairwell. "Did you see that brown man go by?" he asked.

The aide rushed into the stairwell, almost colliding with the day-care director, who was coming down the stairs from her office. "Where did he go?" the aide said.

"Who?" the director asked.

"I saw a man running up the stairs. One of the boys saw him, too."

The two women separated and searched, but the stairwell, the pool and all the adjacent offices were empty.

"Maybe we should call the police," the director said. "What did he look like?"

"I only saw his back," the aide said. "But the little boy called him a brown man."

The director didn't say anything for a few seconds. "One of the best volunteers we ever had was John, an elderly African American gentleman. He used to come every week and read to the kids. Unfortunately, his health declined a few years ago and he stopped coming. John died over the weekend."

The "brown man" isn't the Betsey's only unexplained visitor. Security cameras, which run twenty-four hours a day, are mounted throughout the building. They're mainly used to monitor people entering and leaving, but every once in a while they capture something else.

One Saturday evening, the day-care director was working late in her office above the stage. She was behind in completing her reports, spreadsheets and other paperwork and intended to stay at her desk until she was caught up. After a few productive hours, she decided to go down to the gym and stretch her legs. As soon as she entered the stairwell, she could see that a light was on in the pool area, two levels down. Sighing, she bypassed the gym and continued down to the pool. When she emerged from the stairwell, she was annoyed to see that every light in the pool had been left on. The lights in the corridors and both locker rooms were

blazing, too. Muttering under her breath about the lifeguard who had been on duty earlier that evening, she extinguished the lights and checked the exterior doors, which were locked.

The day-care director's last stop was the long hallway leading to the preschool classroom. When she turned off the hall lights, she noticed light spilling out from under the classroom door. The classroom door was locked. Luckily, her keys were in her pocket. She opened the classroom, switched off all the lights, relocked the door and returned to her office two floors above.

A few hours later, it was finally time to go home. She entered the stairwell and immediately noticed that the lights on the pool level were on again. The rattled director decided they could stay on and left the building as quickly as possible.

On Monday, she told the maintenance supervisor what had happened and asked if they could review the tapes from the security cameras. They found the appropriate portion and watched as the director entered the pool area and switched off the lights. She continued down the corridors and into the locker rooms, turning off lights as she went. When the entire floor, including the classroom, was dark, the fuzzy image of her white blouse disappeared into the stairwell.

Less than one minute later, a woman darted out of the ladies' locker room. The image on the tape was blurry. It was very dark, but she appeared to be wearing a toddler's baseball cap. She moved quickly down the corridor and entered the locked classroom. The mystery woman did not unlock the door; she simply turned the knob and walked in. Lights throughout the pool level flickered on. The woman didn't leave the classroom—not through the door, in any case.

Hearts pounding, the director and the maintenance supervisor hurried to the pool level. The classroom door was still locked. When they entered, the lights were on but the room was empty, and nothing had been disturbed. They spent the rest of the day reviewing security camera tapes. The woman never appeared again, and there was no image of her entering or leaving the building.

PATRIOTS, GOBLINS AND ANCIENT MAGIC

The story of Marietta is written in the stones and monuments of Mound Cemetery. Surrounded by the shady brick streets of a Victorian neighborhood, it is the final resting place of more Revolutionary War officers than any other cemetery in the United States. The American Patriots, along with the local residents who have passed away over the last two centuries, are not alone in the graveyard, however. They share the ground with an enigmatic people who lived and died thousands of years before any of them were born.

MOUND BUILDERS

Mound Cemetery is named for the prehistoric burial mound that rises from the center of the graveyard and casts shadows over the modern tombstones. It is the most mysterious place in town, the subject of weird legends and the setting for countless odd experiences and reports of strange encounters.

Around 500 BC, an ancient people known as the Adena migrated into the valleys of the Ohio River and its tributaries. We do not know

Mound Cemetery and Conus. *Photo by Michael Pingrey.*

where they came from. They lived in the region for about five hundred years before being replaced by the Hopewell. There is no evidence of warfare or conflict between the two groups. Archaeologists believe that they were simply different phases of the same culture. Both the Adena and Hopewell were skilled and prodigious builders. They constructed more than ten thousand mounds and other earthworks in the Ohio River Valley, most of which were destroyed over the last two hundred years. Fewer than one thousand remain.

The Adena and Hopewell constructed a vast ceremonial complex at Marietta. The earthworks included flat-topped pyramids, walled avenues, enormous geometric enclosures and mounds of various shapes and sizes. The ancient people chose to build their massive structures here because this was a mystical place, the perfect site to practice their religion, perform healing rituals, study the movements of the stars, honor their ancestors and bury their dead. The confluence of the Ohio and Muskingum Rivers was certainly an important part of the equation. Flowing water is

a source of great physical and metaphysical energy, and the point where two rivers meet is especially powerful. Constructing the earthworks and performing sacred rites here probably intensified the natural magic that already existed in the environment.

The thirty-foot-tall pyramid that rises from the center of Mound Cemetery is the most spectacular feature in the Marietta complex. It is also the oldest. Rufus Putnam named it Conus because of its shape. Conus is an Adena burial mound. According to archaeologists, it probably contains the remains of dozens, if not hundreds, of individuals. The mound has never been excavated. Not officially anyway.

Conus is surrounded by a circular ditch several feet deep and 220 feet in diameter. Adena ditches are called various names, including sacred circles, ceremonial circles and perfect circles. Sometimes they are referred to as sacred moats, a term that is misleading. There is no evidence that the ditches were ever intentionally filled with water. Their purpose remains unknown.

Conus and its sacred circle. *Photo by Michael Pingrey.*

People gathered at the Marietta sacred complex for more than one thousand years. Around AD 500, they stopped coming. No one knows why. There is no evidence of war, famine, epidemic or natural disaster. The earthworks were simply abandoned. They sat undisturbed for twelve centuries.

DISCOVERY

In 1785, the newly formed American government sent General Josiah Harmar to the Ohio Country to keep peace between the growing population of European squatters and the native peoples living in the area. Harmar built a fort, which he named after himself, at the confluence of the Ohio and Muskingum Rivers. He did not stay long. In 1786, he was replaced by Captain Jonathan Heart.

Captain Heart immediately realized that the massive earthen structures in the area were man-made. He was an experienced military officer used to encountering the unfamiliar in the wilderness of North America. Nevertheless, he had not expected to discover the remains of an ancient lost civilization in Ohio.

Captain Heart surveyed and mapped the earthworks. He then wrote a detailed description of the complex and submitted it to the *Columbian Magazine* for publication. The article, which appeared in 1787, caused a sensation. And it wasn't just men of science and letters who were fascinated by Heart's discovery. The romantic idea that an advanced unknown civilization had once existed in North America captured the general public's imagination as well. The fact that the native peoples living in the Ohio Valley at the time had no idea who had built the mounds only added to the allure. The earthworks were as much of a mystery to the Shawnee, Wyandot and Delaware tribes as they were to the newcomers.

Speculation about the identity of the lost race of master builders began at once. Benjamin Franklin suggested that the Spaniards of the de Soto expedition built the Marietta earthworks, which would have meant the mounds were less than three hundred years old. Other candidates included the Aztecs, Irish, Greeks, Phoenicians, Vikings, "Hindoos,"

survivors of Atlantis and the lost tribes of Israel, all of whom were routinely invoked during the eighteenth and nineteenth centuries to explain the inexplicable.

Thomas Jefferson thought that the ancestors of the Native Americans had built the mounds, but the public and his educated contemporaries rejected that notion out of hand. The vast majority of white Americans refused to even consider the possibility that native peoples were responsible. Constructing the mound complex had required planning, surveying skills and an understanding of mathematics, particularly geometry, not to mention the ability to work cohesively as a group over a long period of time. The "ignorant savages" couldn't possibly have pulled it off.

Even today, there are people who do not believe the ancestors of Native Americans designed and built the earthworks. They think visitors from another galaxy constructed the mounds, as well as other ancient monuments around the world. They point to the fact that several Ohio mounds contained the remains of giants as evidence of extraterrestrial involvement.

The earliest report of gigantic remains dates from 1829 and comes from Morrow County. While building a Chesterville hotel, workers dug into an Indian mound and uncovered an extremely large human skeleton. The local physician who examined the bones said the skull was so big that it fit over a normal man's head like a helmet. The skeletons of three men more than eight feet tall were found in a Noble County mound in 1872. Giant remains were also unearthed in Ashtabula, Brown, Hancock, Lawrence, Marion and Muskingum Counties in the late 1800s.

The giant skeletons are not alien life-forms; they are Adena remains. Only a small portion of the Adena population was buried in mounds. They may have been priests or members of ruling families. We'll probably never know the reason for their special status, but many of the women were six feet, five inches or more and the men were around eight feet tall, at the upper edge of the human height range but still within normal parameters. In fact, tallness may have been part of what made these individuals special. It's easy to perpetuate desirable physical traits through careful intermarriage. This course of action can backfire, however, as members of various European royal houses afflicted with hemophilia, mental deficiencies and various other genetically transmitted problems learned.

THE CEMETERY TAKES SHAPE

Marietta's founders recognized the significance of the ancient complex and took immediate action to protect and preserve the mounds. Conus and the surrounding area were set aside for a public graveyard, later named Mound Cemetery. The first modern burial was the 1801 interment of Revolutionary War veteran Robert Taylor. About thirty Revolutionary War officers are buried in the cemetery, although that number is open to debate.

Record keeping was sketchy in the early days. When someone died, volunteers dug a grave and buried him. Occasionally, the deceased's name, date of death and the location of the burial were recorded. But most of the time, no one bothered. The cemetery was not laid out with plots and avenues as graveyards are today. It was basically an open field. People were buried here, there and everywhere. With alarming frequency, those digging new graves in Mound Cemetery found the ground already occupied.

By the 1830s, the situation had become intolerable. Sextons were hired to look after the cemetery and to impose order on the chaos. They laid out the grid pattern that now exists and began keeping careful records. Sadly, many Revolutionary War veterans passed away before then, which is why the number of officers resting in the cemetery will always be an estimate.

Not all Sons of the Revolution lie in unmarked plots. The graves of many notable Patriots are clearly and correctly marked, including those of Rufus Putnam and Commodore Abraham Whipple, who fired the first shot at the British navy during the American Revolution.

The sextons sometimes uncovered prehistoric artifacts and remains while working in the cemetery. They found an infant's skeleton in the raised berm of the sacred circle, as well as a cache of arrowheads, highly polished stone axes, a block of silver the size of a brick and a mysterious object that looked like a stone corncob near Tupper Street. The infant's remains were reinterred in Oak Grove Cemetery. The current whereabouts of the other items are unknown.

The sextons also modified Conus during the general cemetery improvements of the 1830s. They leveled the top of the mound, creating the flat observation area, and added the stone stairs up the side. When Captain Heart and Rufus Putnam saw the mound for the first time, it was five feet taller than it is now and had a pointier top.

The 1850s saw yet another round of improvements. Prior to the late 1800s, funerals and wakes were held at home. The corpse remained in the house until it was taken to the cemetery. The period between death and burial was usually brief, a few days at most. But occasionally, burials had to be delayed. It could take days for out-of-town family members to arrive, and if the death occurred during the winter, weeks and even months could pass before interment was possible. Without funeral homes or morgues, there was no place to store bodies.

Nahum Ward, former mayor and founder of the local Unitarian church, solved the problem by having a large, sandstone holding vault built. When burials were delayed, the remains were placed in the Ward Stone Vault to await final disposition. Later in the century, as funeral parlors became more common, the need for the vault decreased. It eventually became a toolshed, but even that function ended when the maintenance facility in Oak Grove Cemetery opened.

The years have not been kind to the Ward Stone Vault. Its sandstone has crumbled, and large pieces of it have chipped off. Vaguely sinister looking, it looms behind the rows of flags that honor the Revolutionary War dead. Although crawling into an abandoned corpse holding vault may not appeal to everyone, some local teens found it irresistible. In response, cemetery authorities sealed the opening with bricks so the vault would not be put to "undesirable uses."

Mound Cemetery contains a stone forest of obelisks, shrouded urns and other Victorian symbols of grief and mourning. One of the most poignant is a statue of a weeping woman kneeling atop what appears to be a small Indian mound. Dozens of four-foot-high mounds were scattered around the Marietta earthworks complex, but the weeping woman's mound is not an ancient structure. It's Victorian and was designed to echo the shape of Conus.

LEGENDS, LORE AND A CURSE

Not surprisingly, weird stories and reports of paranormal activity dance around the cemetery like a troop of fairies cavorting under the full moon. The earliest tale dates from 1814, less than thirty years after Marietta's founding. In those days, Conus rose like a mysterious dark sentinel on the outskirts of town. Many believed the mound concealed the golden treasure of the lost race who built the earthworks. The problem, according to the legend, was that no man—as in no male—could access the treasure. Only women had any hope of success.

A band of six bold ladies armed themselves with picks and shovels and approached the mound on a hot and stormy night. They drew a magic circle on Conus's eastern slope and began digging like madwomen. Half an hour later, one of their shovels struck metal. The filthy, exhausted women dug faster and faster. When they heard the jingle of coins, they dropped their tools, fell to their knees and thrust their hands into the mound. At that very moment, a flash of lightning and a deafening crack of thunder exploded above their heads. They looked up and were horrified to see a "goblin damned" standing atop the mound, staring down and pointing at them. The terrified women scattered in all directions, leaving their tools behind. Months passed before anyone—man or woman—was brave enough to return to the mound to retrieve the picks and shovels.

This outlandish story may be based on a real event. The romantic tales of lost tribes and Mound Builders circulating in the 1800s often included references to buried gold and other riches. Local people—maybe even a group of women—may actually have tried to open Conus. They may have uncovered human remains or something else that spooked them. Or local authorities could have cooked up a tale of supernatural danger to keep treasure hunters away from the mound. Regardless of where the story came from, it perfectly captures the aura of weirdness tinged with a little danger that still hangs over Mound Cemetery.

Teenagers, who are drawn to the cemetery like moths, have been terrified by apparitions on top of the mound. Their descriptions are oddly reminiscent of the 1814 goblin legend, which most of them have never heard. Dogs whine and shiver as their owners walk them past the

graveyard fence, and perfectly rational people have seen large things with black wings hovering over the cemetery. The police regularly receive complaints about a man in a long black robe who stands at the cemetery gate late at night. One caller described him as looking exactly like the Grim Reaper.

Amateur photographers and ghost hunters have captured orbs and other anomalies in the cemetery. Others have taken dowsing equipment on top of Conus, where they describe the rods as "going crazy." Graveyards, especially those that contain Victorian-era interments as Mound Cemetery does, are full of buried metal: handles and plaques on coffins, jewelry, cremation urns, personal effects of various sorts and sizes. It's important not to jump to unwarranted conclusions. However, there is no denying the fact that the energy in Mound Cemetery is unusual. And the weirdness doesn't stop at the cemetery fence. It seeps into the surrounding neighborhood, which contains several allegedly haunted houses.

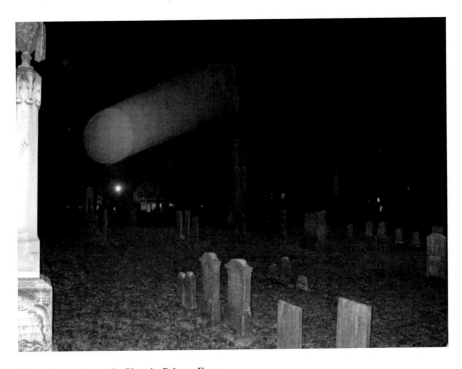

Mound cemetery orb. *Photo by Rebecca Foster.*

The most notorious haunted building in the cemetery's vicinity is a sorority house. Faucets and lights turn themselves off and on, especially in the middle of the night. Doors slam, missing items turn up in odd places and several women have seen the full-body apparition of a well-dressed older man wearing nineteenth-century clothing. Young people away from home for the first time are not the only ones who witness the strange events. Resident housemothers, of which there have been several over the years, are thoroughly convinced there is a ghost on the premises. The Greek Revival mansion, built in 1855, was Governor George White's home in the 1930s, and the ladies call their spirit George in his honor.

And if that isn't enough, there's a curse. It all started, as these things usually do, with a broken promise. The Marietta earthworks complex was built on sacred ground. Longstanding treaties between native peoples and various colonial governments prohibited settlers from moving into the area or using the land for any other purpose. When the new American government gave the land to Rufus Putnam and the members of the Ohio Company, the treaties were broken. In response, a Native American shaman placed a potent curse on the town and its residents, forever.

According to curse proponents, the fact that Marietta's downtown historic neighborhoods were built within the ancient sacred precincts—the public library, for example, sits on top of a large mound—made matters even worse. How the curse manifests is open to discussion. But it does come up on a regular basis, especially when floods, fires and other disasters strike.

There is something extraordinary in Marietta's environment that has drawn seekers for thousands of years. The Adena and Hopewell built their complex here to tap into the sacred forces of the earth. Today, people are returning to the mounds to celebrate the solstices and equinoxes and to mark the changing seasons. They hope visiting at these special times will reawaken the old magic. Others come searching for ghosts and to investigate reports of widespread paranormal activity. Perhaps they are all responding to the same mysterious energy.

GOTHIC MYSTERIES

The Castle, located at 418 Fourth Street, is Marietta's most spectacular historic house. The Gothic Revival mansion, with its stone-capped spires and octagonal tower, was designed by John Slocomb, the architect responsible for the Unitarian church and the Anchorage. The Castle's promotional material includes the phrase "Where History Lives." History may not be the only thing that resides within its soaring brick walls.

GRAPHIC EVIDENCE

A few years ago, the Castle's board became concerned about the antique furniture, carpets and paintings that fill the elegant mansion. They invested in a hygrothermograph, an instrument that measures humidity and temperature and records the data on a single graph. It was placed in the downstairs sitting room. The Castle's director asked the groundskeeper to monitor the device, to check the graphs and to prepare a report for the board's next meeting. It didn't take long for the groundskeeper to realize that a pattern was emerging, but she kept the information to herself until it was time for her formal presentation.

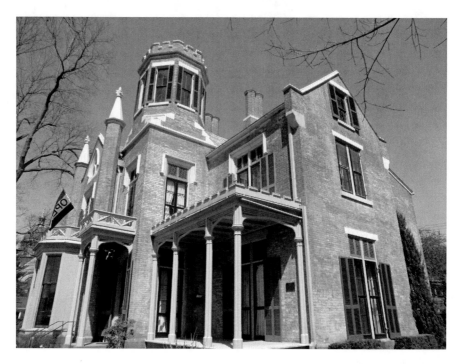

The Castle. *Photo by Michael Pingrey.*

She told the board that according to the hygrothermograph, at precisely two o'clock each morning the humidity in the sitting room jumped and the temperature plummeted. Normal levels always returned within a few minutes, but the simultaneous spikes on the graphs were impossible to ignore. The shaken groundskeeper, who had taken the time to do a little research before the meeting, explained to the stunned board members that sudden temperature and humidity changes were classic indications that a ghost was present. She also informed the board that she had moved the hygrothermograph to other rooms to make sure it was functioning properly and to see if the early morning mystery occurred anywhere else. It didn't. The spikes only appeared when the device was in the sitting room.

Falling temperatures and rising humidity are not the only odd things that happen during the wee hours of the morning. Each October, the Castle hosts a special event for children brave enough to spend the night in the Gothic mansion. The young guests tour the entire house, including

the basement and the tower. They then spend an hour or so listening to ghost stories. At this point, a few children usually decide they don't want to stay. After they depart, the remaining children crawl into the sleeping bags that fill the downstairs rooms.

Not surprisingly, as soon as the lights go off, the girls—and the overwhelming majority of those who stay for the duration are girls—have odd experiences. The ghost stories, the groaning and knocking of an old house settling in for the night, branches clawing at the windowpanes in the autumn wind and the power of the imagination are certainly all factors. But there is something that happens year after year for which there is no obvious explanation.

At two o'clock in the morning—the same time the hygrothermograph in the sitting room registers abrupt changes—those sleeping in the parlor are awakened by squeaking floorboards above their heads. Someone is walking through the upstairs. The footsteps are light and quick. The girls assume that one of their companions has gotten up to use the bathroom, and they go back to sleep. The next morning, when they compare notes and tell the chaperones about their experiences, they are surprised to learn that no one sleeps upstairs during the event. The chaperones explain that the room above the parlor was Jesse Davis Lindsey's bedroom for an incredible eighty-eight years and that Jesse died there five days before her 100th birthday.

The footsteps incident is so predictable that one of the docents, a lady who has spent countless hours volunteering in the Castle, decided to participate in the overnight program to get to the bottom of the story. After the snacks, ghost stories and seemingly endless chatter, she joined the girls in the parlor. She got as comfortable as an adult in a sleeping bag on a hardwood floor can get, and when the girls finally grew quiet, she drifted off.

A few hours later the docent was startled out of a deep sleep. But it wasn't footsteps that disturbed her. She was awakened by moaning. Disoriented, at first she thought it was the wind, but as she became more alert, she realized it was a human voice. She couldn't determine where it was coming from, though. It seemed to be coming from everywhere all at once. Even though the moaning now sounded like a woman wailing,

the sleeping girls sprawled across the parlor floor were oblivious. Too terrified to get up and investigate, the docent slid farther down into her sleeping bag and waited. The pitiful voice continued for a few more minutes and then suddenly stopped. The docent looked at her watch. It was five after two.

The next morning, stiff from a night on the floor, the docent asked the girls how they had slept. They all said they had had a peaceful night's sleep. Not a single one of them mentioned the moaning. No one had heard footsteps either, but the docent knew she'd never doubt anyone who claimed to have heard strange sounds in the Castle again.

ATTIC ANTICS

Two other volunteers had an adventure in the mansion's upper reaches. The women, along with several others, had just completed an all-day training session. It was late afternoon. Some docents were gathering their belongings; others were chatting. Everyone was preparing to leave. One of the experienced volunteers asked a new recruit if she'd like to visit the tower before she went home. She explained that the spectacular view of the rooftops of Marietta and the two rivers made the climb well worth the effort.

After they ascended the long open staircase to the second floor, the senior docent went into a bedroom and opened what appeared to be a closet door. She then led the new docent up another staircase to the attic. From the attic, they climbed yet another flight of stairs—dark, narrow and choked with cobwebs—to the tower, where they pulled down a set of retractable steps that led to the tower's roof.

It was an unseasonably warm October day, and the women slipped off their shoes and leaned back in the warm sun. As they watched the golden maple leaves float onto the Castle's lawn, they commiserated about winter's approach, talked about mutual acquaintances and shared their plans for the upcoming holidays. Before they knew it, an hour had passed.

The docents climbed down the retractable tower steps, walked down the stairs to the attic and made their way down the narrow stairs to the second floor. However, when they reached the bottom step and tried to open the door into the bedroom, it wouldn't budge. It was locked. They pounded on the door and yelled for help. No one responded.

As the shadows in the stairwell deepened and the chill of early evening began to spread through the attic, the senior docent apologized over and over to her new friend. She swore that during her many years of working in the Castle the attic door had never been locked. In fact, she distinctly remembered the board hiring a handyman to disable the lock so that this very thing could never happen.

The women realized that if they didn't find a way out soon, they'd have to spend the night in the attic. In desperation, they climbed back into the tower and out on the roof, hoping to attract the attention of someone on the street or in one of the neighboring houses. Luckily, the last person to leave the docents' meeting heard their cries for help as she was getting into her car. She came back inside and simply opened the attic door. The lock was indeed disabled.

To this day, no one has come up with a plausible explanation of why the women could not open the door. Most of the theories revolve around mechanical issues with the antique doorknob. But the truth may lie in a different direction. When Jesse Davis Lindsey and her sister, Grace, were little girls, the attic was their clubhouse. They decorated it, held meetings and wrote their names on the walls. Adults were not allowed to set foot in their private domain. Perhaps the attic is still off limits to unauthorized visitors.

A FRIENDLY GESTURE

Antique trolley tours operate in Marietta throughout the summer and fall. On Halloween, the trolley makes a special run through the old neighborhoods as the conductor tells the town's most notorious ghost stories. A few years ago, the conductor called the Castle and asked if

the staff would be willing to make the house look haunted. The staff agreed and decided to focus their spooky decorating efforts on Jesse's room. Her bedroom windows look down on the spot where the trolley planned to park.

They brought a dress form, which is a headless mannequin, and placed it at the windows. They clothed the figure in a long Victorian gown, raised one of her arms as if she were waving and wired it securely into place. The docents were quite pleased with their headless friend, but they were worried that the trolley passengers would not get the full effect without special lighting. They placed a floor lamp behind the mannequin, and when it got dark, they stood in front of the house to see how it looked. The floor lamp was too bright. The following evening they left the hall light on, but it was so dim that the mannequin didn't show up at all. The next day was Halloween, and the Castle was so overwhelmed with visitors that the exhausted docents forgot about the trolley tour. When it was time to go home, they turned off all the lights and left.

The next morning, the trolley conductor called to thank the Castle staff for doing such a great job. She said the lighting was perfect and the whole tableau was so creepy that the passengers sitting in the rear of the vehicle swore they saw the headless woman's hand move as the trolley pulled away.

LINGERING VIBRATIONS

Wealthy Victorian ladies, like those who lived in the Castle, often consulted mystics, mediums and fortunetellers. In honor of this nineteenth-century cultural phenomenon, the Castle recently invited four local psychics to offer public readings in an authentic historic setting. The readers came the night before the event for a private tour of the house. The executive director had decided not to tell them anything about the mansion's history or the people who had lived and died within its walls. She simply welcomed them to the property and suggested they wander around. She told them she would be quite interested in what they felt and sensed as

they made their way through the house. A volunteer was on hand to accompany the group and take notes.

According to the psychics, the sitting room, where the hygrothermograph was placed, crackled with tension, residual anger, jealousy and resentment. Two of the upstairs bedrooms were heavy with illness, suffering and grief. The parlor and dining room were quiet and empty, utterly deserted. But the oldest part of the house, the summer kitchen, seethed with energy. The four sensitive visitors all picked up similar vibrations: a group of prominent men, a secret meeting, a political discussion, an intense argument, a dangerous plan and talk of treason.

After the group left, the director and the volunteer pored over the notes. As far as the director was concerned, the emotions and feelings the psychics felt had the ring of truth. Many of the Castle's residents had led turbulent and unhappy lives. It was the mysterious meeting in the summer kitchen that piqued the director's interest, however. Did it really happen? Who attended and what were they discussing? Many wealthy and powerful people have passed through the Castle's doors over the years. Research into this matter is underway.

RIVER PHANTOMS

Without the Ohio and Muskingum Rivers, Marietta would not exist. It's a river town through and through. The rivers brought settlers, commerce and prosperity to the valley. They also brought death, destruction and great misery. Marietta has suffered through eighteen spectacular floods since its founding. Those were the big ones, the ones worth noting. Minor flooding occurs almost every year.

Today, the majority of Marietta's residents and visitors view the rivers as assets. The truly optimistic point out that the killer floods of the past deposited the rich soil that makes the farms in the area so productive. But everyone in the valley keeps an eye on the weather and the water levels. The rivers will rise again. The only question is when.

Floods aren't the only danger associated with the rivers. Hundreds, possibly thousands, of people have lost their lives in the Ohio or in the Muskingum. Some deaths were accidental, others were suicides and many were the result of foul play.

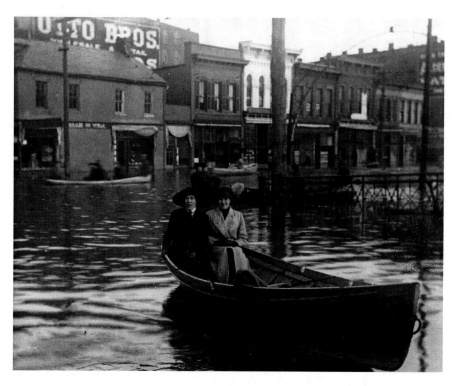

Inspecting the damage, 1913 flood. *Courtesy of the Washington County Historical Society.*

PILOTS AND GUIDES

Thanks to a system of locks and dams and the work of the Army Corps of Engineers, today the Ohio River is relatively tame. The early settlers encountered a very different waterway. In the late 1700s, the Ohio River was the main artery to the new territories of the west. Parties of settlers traveled overland to Pittsburgh, where they paid substantial sums of money to board small, flat-bottomed boats that were little more than rafts. Most of them had never set foot on a boat and knew nothing about river navigation. They did not let that stop them from loading their wives, elderly parents, children, livestock and all their belongings onto flimsy vessels that experienced sailors wouldn't trust in a shallow pond. They careened downstream on the swift and ever-changing currents, trying to anticipate upcoming twists and turns, maneuver through rapids and avoid snags, sandbars and other hidden threats. As if that weren't

enough, hostile Indians lurked in the woods that lined the banks. Yet even with the well-publicized, substantial dangers, they kept coming. Nothing was going to stop the westward expansion, and those who lived along the main routes found ways to profit from the settlers—some legal, some not.

Enterprising boys in Pittsburgh sold charts of the Ohio River to settlers renting boats. The charts helped a little, but the situation improved drastically in 1801, when a man named Zadok Cramer published a book called *The Ohio and Mississippi Navigator.* Cramer's travel guide, which quickly became a bestseller, included the following bit of advice: "There is a person who is sometimes employed to pilot boats throughout serpentine channels and it is better for a stranger to pay a dollar or two for this purpose than run the risk of grounding." That seemingly innocent sentence attracted the attention of a highly specialized audience: pirates.

Pirates were a major threat on the inland waterways. Unlike their counterparts on the high seas, who had a colorful reputation even in their own time, river pirates were viewed as thugs and murderers. Prior to the publication of Cramer's book, they had contented themselves with simply attacking and overpowering settlers as they floated down the river. The pirates traveled in fast, light canoes, and the settlers were ridiculously easy targets. *The Ohio and Mississippi Navigator* inspired the pirates to develop a new approach.

A member of a pirate band would station himself along the riverbank. His job was to hail passing boatloads of settlers, identify himself as the river expert recommended in Cramer's book and offer his navigation services. If the settlers declined, he did not press the issue. He wished them well and melted back into the forest. He knew they would soon be in rough water, questioning their decision to go it alone. Besides, another member of his band was poised to make the same offer as soon as the wobbly boat, with its increasingly nervous passengers, emerged from the rapids.

If the settlers still refused help, fine. Another pirate posing as a river navigation expert was waiting farther downstream on the other side of yet another dangerous stretch of water. Most of the settlers eventually succumbed. They welcomed the fake river pilot aboard and gave him control of the boat. He promptly steered it to a prearranged spot, where

the rest of the pirate band was waiting, and grounded it. The pirates stole everything and killed everyone, including small children.

The pirates had plenty of places to hide and stash their loot. The woods were thick, dark and choked with undergrowth. Ancient trees lined the riverbanks, and there were shady creek mouths, hidden caves and islands of various shapes and sizes. Pirates continued their brutal attacks until the dawn of the steamboat era. Their canoes were no match for the bigger and faster vessels that quickly came to rule the waterways.

BUCKLEY'S ISLAND

Some of the islands the pirates used as hideouts still exist. They are scattered along the four-hundred-mile course of the Ohio River as it winds its way through Pennsylvania, West Virginia, Ohio and Kentucky. One of the largest, Buckley's Island, lies near the mouth of the Muskingum River, adjacent to downtown Marietta. Today, it is part of the Ohio River Islands Wildlife Refuge, home to a wide variety of waterfowl. But like the town, its placid appearance masks a turbulent past.

During the Victorian era, there was a large and popular amusement park on Buckley's Island. Pleasure boats picked up passengers in Marietta and transported them to a fantasy world of rides, carnival attractions and vendors offering delicious treats like cotton candy and lemonade. Other diversions and refreshments of a more adult nature were available after the sun went down. Even though the island is only a few hundred yards from the Marietta levee, it is part of West Virginia. The Marietta police had no jurisdiction, and the village of Williamstown, West Virginia, on the opposite shore, had no police force. Buckley's Island became a haven for illegal activities, including gambling and cockfighting. And if a visitor worked up a thirst, beer was available for a fraction of the price charged in Marietta's many taverns.

The 1913 flood demolished every structure on the island, putting an end to the amusement park and to the other island activities. Buckley's Island became a lonely place. Some say an oppressive, hopeless atmosphere

hangs in the air. This residual energy is not an artifact of the amusement park days. To find its source, we must travel further back in time.

From 1793 until the mid-1820s, Buckley's Island was where people were sent to die. Outbreaks of infectious diseases were common on the frontier, and once an epidemic took hold, there wasn't much anyone could do other than wait it out and pray. Smallpox, yellow fever, malaria, cholera, dysentery and influenza rose up with regularity, wiping out entire families and decimating communities before subsiding, only to surface again.

Summer and fall were the most dangerous seasons. Doctors blamed the outbreaks on the weather. Both excessive rain and drought were cited as causes, as were stagnant water, hot southern winds and "foul scum" on brooks and streams. A lack of thunderstorms was also a problem. People believed that lightning purified the atmosphere, and the strong northwest winds that often accompany such storms blew away the noxious disease-causing vapors.

Marietta's worst plague years were 1793, 1807, 1822 and 1823. These were not the only times epidemics visited the settlement, but these years saw the most fatalities. Although many people recorded descriptions of the symptoms, it's impossible to know for sure what illness afflicted the population in those awful summers. It was probably a combination of yellow fever, malaria and influenza. Smallpox was part of the hellish mix in 1793.

With no real treatment options, almost everyone who contracted the fevers died. People may not have understood the real cause of the epidemics, but they knew the diseases were highly contagious. And this is where Buckley's Island enters the story.

The settlers built a shelter on the island, a Pestilence House, or Pest House for short. They were not without human feeling. They hoped the victims—who were their friends and family members, after all—would be comfortable and not suffer too much at the end. But their main concern was protecting the healthy and stopping the spread of the disease. So victims were taken to the island to die, a fact that was not lost on those still conscious as they were loaded onto boats for the short one-way trip. Men, women and children were abandoned in the Pest House. Some

were confused, raving mad, delirious with fever; others lay quietly, fully aware of their fate. All were sick and frightened. It is the echo of these poor souls' soft moans that mingles with the cries of the herons and geese. It is their sad energy that haunts the island today.

Watery Deaths

Samuel Holden Parsons, a justice of the Northwest Territory Supreme Court, was the first person to drown after Marietta's founding. His death in a canoe accident in November 1789 established an unfortunate trend. People have died in or near the rivers every year since. The following reports from the early 1800s are typical:

May 1814: The body of a seventeen-year-old woman is found floating in the Ohio. Her hat is retrieved several miles downstream a few days later.
June 1814: George Edwards, aged twenty-one, falls off the *Lady Washington* and drowns in the Ohio.
November 1814: A farmer finds the body of a drowned man, clothed but barefoot, caught in tree roots on the bank of the Ohio four miles from Marietta.
April 1816: Samuel McClintick, a "respectable citizen," drowns in the Ohio.
August 1816: The injuries on a body pulled out of the Ohio lead the coroner to conclude that the man was murdered prior to being thrown into the water.

And on it goes.

Of all the river tragedies, the *Buckeye Belle* disaster holds the unfortunate distinction of being the most gruesome. The *Buckeye Belle* was a side-wheel steamboat that made regular trips on the Muskingum River between Marietta and Zanesville, about sixty miles each way. In 1852, the year of the disaster, it was the largest passenger vessel operating on the Muskingum.

Late on the cold and misty afternoon of November 12, the doomed steamboat pushed away from the Marietta riverbank and headed

Passengers aboard the Muskingum River steamboat the *Annie Laurie. Courtesy of the Washington County Historical Society.*

north. There were a number of prominent people among its forty-five passengers, including a state senator and two state representatives setting out on the first leg of their journey to Columbus for a session of the Ohio General Assembly.

Mr. A. Layman, the editor of the *Marietta Republican* newspaper, and his wife settled into the Ladies' Cabin, a special area set aside for female passengers and their traveling companions. The Ladies' Cabin was warmer—a definite plus on a dreary afternoon—and it had a door that could be closed to shield sensitive female ears from the raunchy language occasionally heard on deck. The Laymans joined several women, State Senator Covey, a sixteen-year-old boy with the unusual name of Plus Padjitt and Miss Charlotte Stone, the grandniece of Marietta founder Rufus Putnam.

The trip was routine until they reached the town of Beverly shortly after 5:00 p.m. As the boat entered the calm waters of the Beverly canal to wait its turn to pass through the lock, the *Buckeye Belle* exploded. The

fire turned the sky crimson, and the force of the blast hurled burning splinters of the boat hundreds of yards into the surrounding woods, igniting the dry autumn leaves that covered the ground.

Many passengers and crew died instantly. Some were scalded to death by the escaping steam. A few jumped into the canal and drowned. Most were simply blown to bits. Body parts rained down into the river and landed on the rooftops, porches and gardens of the horrified residents of Beverly.

The only portion of the *Buckeye Belle* that escaped total destruction was the Ladies' Cabin. Although it eventually collapsed, about fifteen feet of the rear section of the compartment survived the immediate effects of the blast. No one in that section was seriously injured, but utter and complete panic took over. The only person who kept her wits was Miss Charlotte Stone. She blocked the door, preventing several women who could not swim from jumping into the icy canal. In the confusion, a terrified woman knocked over the coal stove, setting fire to the carpet. Charlotte grabbed a blanket from the settee and smothered the blaze. Thanks to her cool head and decisive actions, everyone in the Ladies' Cabin survived.

Plus Padjitt had left the Ladies' Cabin and stepped onto the main deck moments before the explosion. He was thrown more than seventy-five feet through the air and landed on the floating remnants of the *Buckeye Belle's* bow. Although his hair was burned off and his body was scalded from head to toe, he survived.

At sunrise the next day, the people of Beverly formed teams and combed the town, woods, fields and riverbanks searching for human remains. Because of the passenger manifest, they knew who had been aboard the *Buckeye Belle*. Thirteen people were missing. The material they found was mutilated, most of it unrecognizable. They solemnly placed the bones and tissue fragments in a large box and buried it in the town cemetery. The plot, which can still be visited, is marked by a large granite boulder bearing a bronze plaque that reads, in part, as follows:

Here lie buried thirteen unknown persons
Killed by the bursting of the boiler of the
Steamer Buckeye Belle
November 12, 1852

Buckeye Belle monument, Beverly Cemetery. *Photo by Lynne Sturtevant.*

Of the forty-five souls on board, twenty-one died the day of the explosion. Three more, including State Senator Covey, succumbed in the days following the disaster. Another eleven lived out their days blinded, crippled and otherwise permanently maimed. Ten people escaped injury completely, including Miss Charlotte Stone, who lived to be one hundred. The *Buckeye Belle* tragedy remains the worst disaster in the history of navigation on the Muskingum River.

Steamboat boiler explosions were frighteningly common in the nineteenth century. But the spectacular nature of the *Buckeye Belle* incident attracted national attention. It was covered in newspapers from coast to coast, and wild rumors about the accident began circulating immediately. According to one popular but unsubstantiated story, a baby boy whose name did not appear on the passenger list was thrown thirty feet through the air and landed unharmed atop a haystack. Another tale involved the *Buckeye Belle*'s missing safe, supposedly full of gold, silver and other valuables. It was retrieved from the muddy bottom of the Muskingum

in 1871, nineteen years after the explosion. With reporters and curious members of the public looking on, the safe's door was pried off with crowbars, an event that oddly foreshadowed the televised opening of the *Titanic*'s safe more than a century later. The outcome was the same in both cases: neither safe contained anything of value.

Those who have spent their lives along the banks of the Muskingum say a ghost ship returns to the river each November. No one has ever seen it, but the old-timers swear that on drizzly autumn afternoons, as the sun begins to slip behind Harmar Hill, if you listen carefully you can hear the mournful echo of the *Buckeye Belle*'s whistle as it heads upstream toward Beverly and eternity.

Ghost ships aren't the only phantoms along the Muskingum. Many have had the unnerving sense that something unseen lurks near the Muskingum River docks after the sun sets. This may be related to the *Buckeye Belle* disaster, too.

The movie *The Sixth Sense* introduced many people to the intriguing notion that people can die and not realize they are dead. Although it may seem like nothing more than a clever literary device, the idea is quite ancient and surfaces in cultures all over the world. The phenomenon arises when young and healthy people are killed instantly and unexpectedly.

When this sort of catastrophe occurs in a Buddhist country, monks immediately converge on the accident scene and begin meditating, chanting and praying. They believe the souls of some of the victims linger in the area. The newly deceased are confused and disoriented. They do not understand what has happened to them, and they have no idea what to do next. The monks help them make the transition. They continue their rituals until they are sure everyone has successfully crossed over and is at peace. The entire process usually takes about four days.

No one came to comfort the victims of the *Buckeye Belle* or to guide the other young people who have died suddenly in the dark waters of the Ohio and the Muskingum over the years. Are they the lost spirits who wander the riverbanks? If so, these entities are not to be feared. They just need someone to help them find their way home.

HAUNTED HARMAR

Harmar, directly across the Muskingum River from downtown, is the oldest part of Marietta. In 1785, a contingent of newly minted American troops was sent to the Ohio Valley to protect the native people from settlers who were overrunning the area in violation of treaties. The soldiers built Fort Harmar, named after their commanding officer, on the west side of the Muskingum. Three years later, in 1788, Rufus Putnam and the Ohio Company arrived and established the settlement of Marietta on the eastern bank, sparking immediate competition between the two sides of town. By 1835, west side residents were so fed up with their counterparts on the other side of the river that they filed for divorce. Their vote to officially secede from Marietta established Harmar as an independent village. It had always had its own identity, but now it also had its own charter, elected officials and post office.

The economic boom of the late 1880s put everyone in a better mood. Oil and natural gas had been discovered in the area, the population was growing, new businesses were springing up and the time seemed right to consider reconciliation. So in 1887, the Marietta Board of Trade approached the mayor of Harmar and proposed reunification. It took a few years to work out the details, but the two sides eventually reached

a tentative agreement. In 1890, the citizens of Harmar chose to rejoin Marietta. The measure carried by a slim ninety-vote margin.

Historic Harmar Village, as the commercial area is known today, has a charm all its own: brick streets, shops, restaurants, museums, restored train cars and historic buildings. It has a different, quieter feel than Marietta. But there is one thing that both sides of the city share. Just like the east side, the west side is full of ghosts.

HAMMERED

In the heart of Historic Harmar Village, at 109–111 Maple Street, sits the Marietta Soda Museum, one of the region's quirkiest attractions. The old double building has passed through many owners and has had many names, but for most of its long life the first floor has been the tavern of choice for west-side residents. Visitors can still belly up to the gleaming wood bar and order a drink—as long as it's nonalcoholic. The Soda Museum serves soft drinks, hand-dipped milkshakes and ice cream sodas, along with a variety of other old-fashioned treats. Patrons enjoy their beverages surrounded by a mindboggling array of American soda memorabilia, most of which celebrates Coca-Cola and all of which is for sale. There are thermometers, bottle openers, cookie jars, metal signs, trays, coolers, playing cards, canisters, key chains, napkin dispensers, Christmas ornaments, salt and pepper shakers, drinking glasses, shot glasses, coffee cups, mirrors, paper weights, cigarette lighters, ashtrays, T-shirts, refrigerator magnets and coasters. An assortment of old gasoline pumps completes the décor.

Today, there are three nice apartments upstairs, but in the early 1900s the second floor was a seedy boardinghouse. Tiny sleeping rooms lined a long, narrow hallway, and most of the tenants were transient railroad workers. By the 1940s, prostitutes had moved in, and they operated out of the premises for several decades.

Many Harmar residents remember Maple Street in the middle years of the twentieth century as the roughest part of Marietta. In those days,

the building that now houses the Soda Museum was a beer joint called the Maple Café. On Sunday mornings, the neighborhood kids got up at the crack of dawn and rushed to Maple Street to scoop up the coins and bills that the drunks had dropped the night before as they staggered home. In addition to loose change, the brick sidewalks were always littered with teeth, fistfights and brawls being an essential part of the Maple Café experience.

People have had paranormal encounters in the Maple Street building for decades. Previous residents often heard unexplained footsteps bounding up the stairs. That element of the haunting seems to have stopped. It might have been a residual that ran its course and dissipated. Or maybe whoever it was moved on. At least one spirit, however, remains, and he is interested in construction projects.

Former tenants reported hearing hammering upstairs. It happened while the building was undergoing renovations but always after the workers had left for the day. A railroad carpenter died in one of the small second-floor rooms in the early 1900s, and at least one resident thought his spirit might be the culprit. The Soda Museum owner agrees. After he acquired the building, he had to remodel it to accommodate his vast collection of paraphernalia. He also had the second-floor apartments spruced up. Each afternoon, the workers dropped their tools and left them wherever they happened to be when quitting time rolled around: in the bedrooms, hallway and bathroom or on the stairs. Yet each morning, when they returned, they found their tools all together, carefully lined up, arranged according to size and function.

There is a theory that renovating old buildings stirs up dormant paranormal energy. This certainly seems to be a factor at the Soda Museum, but there may be more to the story. If the spirit really was a carpenter in life, the affinity he feels for the trade could be what's drawing him out. He may just want to be one of the guys.

THE HOUSE ON HARMAR HILL

The man who built the Queen Anne mansion atop Harmar Hill had clear goals. He wanted the most impressive house in the best location with the most beautiful view in town. His Victorian showplace featured not one turret but two, spires, gas fireplaces, colorful tile, elegant mantels, sparkling bay windows, leaded art glass and a gorgeous open staircase.

The house was completed in 1901. It was everything he had hoped for and more. As he settled into a wicker rocker on his grand wraparound porch and sipped his early evening cocktail, he must have felt like an English lord surveying his domain. The newly installed electric lights of Marietta twinkled at his feet. Beyond the confluence of the rivers, the Appalachian foothills stretched into the blue distance. It was hard to imagine how life could be any better.

The lovely old house still sits atop the ridge. Its current residents, only the third family to call it home, have transformed it into a bed-and-breakfast. Known simply as the House on Harmar Hill, the mansion has reclaimed its lofty position as the area's most elegant home. Guests come and go, and the owners occasionally leave town, but the House on Harmar Hill is never completely empty. The old Queen Anne is haunted.

The owners never mention the ghost to their guests. Some remain happily oblivious to the fact that they are sharing the house with an unseen entity. Other guests pick up on the haunting immediately. Several people have reported sensing a presence in the second-floor corridor. The lady of the house has felt the presence, too, but usually in the kitchen. She says at times the feeling that someone is watching her is so strong that she turns or looks over her shoulder to see who is there.

The owners lived in the house while the renovations, which were extensive, were underway. They took lots of before-and-after photos as the work progressed. Anyone who has lived through a home construction project knows how exhausting it can be. At the end of a particularly discouraging week, the couple sat down and looked at their home improvement pictures to remind themselves of how much had been accomplished. When they were through, the wife put the pile of photos on the jelly cabinet in the dining room, and the couple went to bed.

The House on Harmar Hill. *Photo by Michael Pingrey.*

The next morning, she went to the dining room to look at the pictures again. They were gone. When she asked her husband what he had done with them, he swore he hadn't touched them. They looked everywhere but could not find the pictures. Several months later, the wife walked into the kitchen and was shocked to find the photos neatly stacked on the counter. She called out to her husband, who was watching TV in the next room, and asked him where on earth he had found them. He had no idea what she was talking about.

The first summer the couple lived in the house, the front doorbell often rang while the wife was home alone, but when she answered the door, no one was there. She told her husband what was going on, and they assumed a neighborhood kid was playing pranks. But as the incidents increased and no one was ever seen on the porch or even in the house's vicinity, they started to wonder. Then, both the interior and exterior lights started flickering and turning themselves off and on. There were workers in the house throughout the summer who repeatedly checked for

electrical shorts or other factors that could cause the bell to ring or the lights to blink. Nothing physical was ever found.

In July, friends and family gathered in the House on Harmar Hill to celebrate the husband's birthday. Everyone settled into the big chairs on the front porch and began reminiscing. The group included a twelve-year-old boy who quickly grew bored and retreated to the owners' private third-floor suite to watch TV.

The boy returned to the porch a few hours later and asked why no one had answered the door. His question was met with confused stares. He said someone had rung the doorbell repeatedly, interrupting his TV viewing. His mother assured him that no one rang the bell. She pointed out that she and several of his closest relatives had spent the entire afternoon enjoying the river view and there had never been a time when the porch was empty. He insisted that someone had rung the bell. It was clear that an argument was about to erupt, so the lady of the house stepped in and told her stunned friends and family about her own experiences with the invisible doorbell ringer.

Later that year, the couple hosted a Christmas open house. The previous owners attended the party. After a few glasses of holiday cheer, one of then took the wife aside and asked, "Have you seen him?"

"Who?" she said.

"The ghost." He smiled. "Surely you've realized the house is haunted."

"Who is he? Or was he? Why is he here?"

The former owner shrugged and poured himself another drink.

Over the next few months, hints about the ghost's identity surfaced. The husband likened the process to watching an old-fashioned Polaroid picture slowly develop. The ghost is definitely male. He is a strong presence, and he seems to be alone. The owners are not afraid of him, although he has startled them from time to time.

One night, the couple was sound asleep on the third floor. The B&B was full of guests. About 3:00 a.m., the husband awoke and was shocked to see a man standing at the foot of their bed. Assuming it was one of the guests, he asked the intruder what he needed. The man didn't answer.

The owner of the House on Harmar Hill is a retired U.S. Air Force pilot, trained to remain calm, alert and observant. Now fully awake, he

began mentally noting the details of the man's appearance. The stranger was about six feet tall with a slender build, probably in his late thirties. His dark hair was parted on the side and slicked back. He was wearing baggy black pants, a cardigan sweater and a white shirt with a starched, stand-up collar.

"What do you need?" the owner asked again.

The man removed his hands from his pockets and extended them toward the bed, palms up. At this point the owner's wife woke up.

"Who are you talking to?" she asked.

"Him!" he said pointing at the man.

"There's no one there. You're dreaming."

"Are you saying you can't see him?"

The tall man shifted his gaze to the wife, stared at her a few seconds and then dematerialized, fading away like a puff of smoke.

A few weeks later, the couple found a box of old photos, including one of the house's second owner. The husband recognized him immediately as the man who had stood at—and disappeared from—the foot of their bed. Further research revealed that the man in the picture had died young. His widow lived alone in the house for many decades after his passing. The owners think he may have stayed to watch over her and for some reason does not realize that she's gone.

The ghost is not active all the time. When the house is calm and quiet, so is he. Renovations agitate him, but crowds of people stir him up more. The second owner was famous for throwing great parties. The third floor, where the sighting occurred, was the ballroom in his day, and according to all accounts, it was the scene of some outrageously good times. Maybe he still wants to be part of the action.

Neither of the current owners had given much thought to the supernatural before moving to the House on Harmar Hill. They believe in ghosts now, though, and as far as they are concerned, the gentleman who materialized at the foot of their bed is just as welcome as all the other guests who come to the B&B. Although they do wish he'd leave the front doorbell alone.

THE PALACE BEAUTIFUL

The house featured in this chapter has had various names through the years, including Putnam Place, the Putnam Villa, the Marie Antoinette Home and the Christian Anchorage Nursing and Rest Home. John Knox, the second owner, christened it the Anchorage when he added a large driveway shaped like a ship's anchor to the property. The Washington County Historical Society, which now owns the house, calls it the Putnam Villa/Anchorage. For simplicity's sake, I will refer to it as the Anchorage.

THE PUTNAMS

In the 1850s, Douglas Putnam was the richest man in Marietta. A community leader, he served on the boards of several banks and was one of the founders of Marietta College. He was a quiet, modest, pleasant man, married to a woman who was his exact opposite. Eliza Whipple Putnam was intelligent, intense and opinionated. From a prominent and wealthy family in Zanesville, Ohio, Eliza was, above all else, status conscious. People in Marietta viewed the Putnams as akin to nobility, an image that delighted Eliza and made Douglas uncomfortable.

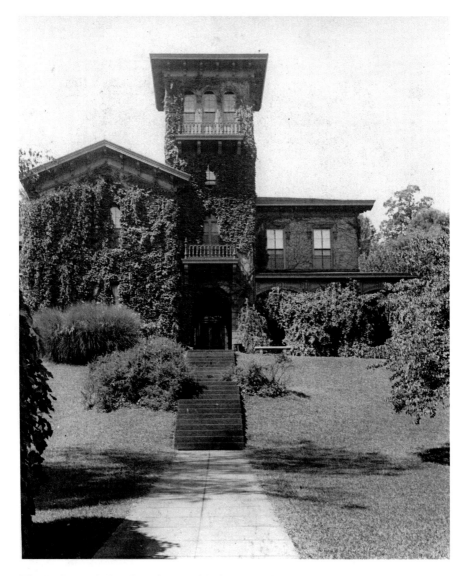

The Anchorage in its prime. *Courtesy of the Washington County Historical Society.*

In 1852, Eliza traveled to New Jersey to visit a friend who had just moved into an enormous custom-designed house. As Eliza walked through its seemingly endless rooms and marveled over its many modern amenities, she promised herself that she would have an even grander house built as soon as she returned to Ohio.

When she informed Douglas of her intentions, he was less than enthusiastic. He would have been happy living in a shack. But he did not like conflict, and he wanted to please his wife. He hired noted local architect John Slocomb, and plans for Eliza's dream house were begun.

Construction on the fabulous Italianate mansion that came to be known as the Anchorage began in 1854. The twenty-two-room sandstone villa took four years to complete and cost $60,000, about $1.5 million in today's dollars. The house was built in Harmar on a hillside so that the lady of the manor could gaze down on the town. The society pages referred to it—even before construction was completed—as "the Palace Beautiful."

During the four years of construction, Eliza oversaw every detail. She knew exactly what she wanted and had no tolerance for shortcuts or compromises. As the walls rose, she imagined how jealous her New Jersey friend would be when she realized the Anchorage surpassed her home in every conceivable way.

Eliza was a pragmatic, politically savvy woman, and as she fussed over furniture, carpeting and draperies and dreamed of the formal balls, lavish dinners and grand parties she would host, she kept one eye on the growing tension between the North and the South.

The Underground Railroad

Today, Marietta, Ohio, and Williamstown, West Virginia, are linked by a short bridge across the Ohio River. Hundreds of people pass back and forth each day without giving it much thought. In Eliza's time, things were very different. There was no bridge, Williamstown was in Virginia, the Ohio River was the boundary between the slave states of the South and the free states of the North and Marietta was a stop on the Underground Railroad.

The Underground Railroad was a secret network of antislavery activists, known as abolitionists, who helped slaves escape and make their way north to freedom. The network relied on code words, constantly changing

routes, safe houses, hidden rooms and all kinds of deception and disguises. "Underground" referred to the organization's clandestine nature, and although underground tunnels were occasionally used as temporary hiding places, the actual escape routes were above ground through fields and forests and along creek beds, rural back roads and cow paths.

The effort to assist escaping slaves was gaining momentum at the same time the nation's railroads were expanding. The abolitionists climbed on board, so to speak, and developed a secret code based on railway terminology. Those who helped slaves learn about the Underground Railroad were called agents, guides were known as conductors and safe houses and other hideouts were called stations. The owners of the safe houses were stationmasters, and the escaped slaves themselves were referred to as passengers or cargo.

Douglas and Eliza could stand in the tower of the Anchorage and look across the river into Virginia, which must have disturbed them greatly. The Putnams had strong ties to the antislavery movement. Douglas's brother, David, was the area's most outspoken abolitionist. He made no attempt to hide the fact that he was an agent for the Underground Railroad, and his modest house, which was on the grounds of Douglas and Eliza's mansion, was known to be an Underground Railroad station. David was arrested numerous times for hiding runaways in his home and for inciting slaves to escape, and he was even involved in a landmark lawsuit brought by the owners of Henderson Hall, a Virginia slave plantation only two miles from Marietta.

David wasn't the only member of the family connected to the cause of freedom. Eliza was an ardent and very vocal abolitionist, just like her father, Levi Whipple, who is listed among the Underground Railroad agents in Muskingum County. Douglas's role in the antislavery movement is not as clear. Working on the Underground Railroad in any capacity was not only dangerous, but it was also illegal. Most local historians think that Douglas, a cautious and conservative man, would have shied away from such a risky activity. It's hard to believe, however, that his incredibly strong-willed wife and equally intense brother did not convince him to get involved on some level. Whether evidence of that involvement still exists within the Anchorage is a source of ongoing debate.

Many older people swear that as children they saw tunnels in the mansion's basement. They were told that the tunnels were part of the Underground Railroad and that they led to the Muskingum River. The tunnels are real, and they still exist, but they do not lead to the river. The distance is too great. Problems with air supply would have been insurmountable, and there would have been significant cave-in dangers. The Anchorage's hillside is full of springs, and the tunnels were built for drainage. Without them, the ground would be soggy and unstable, and the huge house would be at risk. But the fact that the tunnels were constructed for utilitarian purposes does not mean they were never used for anything else.

Marietta was on the front lines during the Civil War, located only a few hundred yards from Virginia. There was a constant nagging fear that Rebel forces would invade and sack the town. Wealthy people devised all sorts of ingenious hiding places to stash their jewelry, cash and other valuables in case of enemy attack. The drainage tunnels may have come in very handy. But gold watches, garnet brooches and stock certificates may not have been the only valuables that were concealed in the Anchorage. According to a persistent story, a rope ladder in a hollow space between the kitchen walls led to a secret room in the basement where runaway slaves could rest until it was safe to travel to Zanesville, where Eliza's father and his associates would forward them on to Canada and safety.

Some local historians discount these stories as legends. They say that the heyday of the Underground Railroad was over by the time Douglas and Eliza began building their house. That's clear in retrospect, but the Putnams could not have known that in 1854. Given the intensity of the extended family's feelings on the issue of slavery, it's hard to imagine that they would not at least have discussed the possibility of building secret rooms into the Anchorage. For many, the four-foot-high hidden compartment beneath the kitchen, which can still be seen today, proves the stories are fact, not fiction.

With or without secret rooms, the Anchorage was completed late in 1859. The Putnams moved into their new home in time to celebrate Thanksgiving. Less than three years later, the bay window in the lavishly

decorated parlor contained Eliza's flower-draped coffin. She passed away in her beautiful bedroom at the age of fifty-three from heart disease. She did host a few parties. Due to her declining health, however, her soirées, although lovely in every way, were small, low-key affairs. She went to her grave with her desire to reign over Marietta's social scene largely unrealized.

Soon after Eliza's death, Douglas remarried. Some of Eliza's friends found the speed with which Douglas replaced his wife unseemly. Their opinions did not faze the new Mrs. Putnam. The former Sara Dimond of Massachusetts assumed the role of Marietta's most prominent hostess without missing a beat. She held elegant dinners, charity balls, concerts and fancy parties. It was her house that tourists gaped at from the street below and her name that appeared in the society pages over and over. She ended up with everything Eliza had dreamed of, planned for and worked so hard to obtain. Ironically, the new Mrs. Putnam didn't particularly care for the Anchorage. When Douglas died in 1894, she sold it for $12,000, a fraction of what is was worth, and immediately moved to Kansas. She never visited Marietta again.

LIVING LARGE

After the Putnams, the house passed through several hands. In 1918, it was purchased by its last private owner, Edward MacTaggart. Oddly enough, Eddie, as he was known, had ties to the Underground Railroad. He grew up on his great-grandfather's farm outside Williamstown. According to MacTaggart family tradition, the farm was an Underground Railroad station, and fugitive slaves hid there until they could be forwarded to the Anchorage. He said it was one of the reasons he bought the house.

Eddie was an oilman who had graduated with honors from Marietta College. By the time he was forty-seven, he had made enough money in Oklahoma to retire. He returned to Marietta, bought the Anchorage and spent the rest of his life improving the property, supporting his alma mater, contributing to assorted charities, throwing fabulous parties and generally playing the role of Marietta's most flamboyant, eccentric and

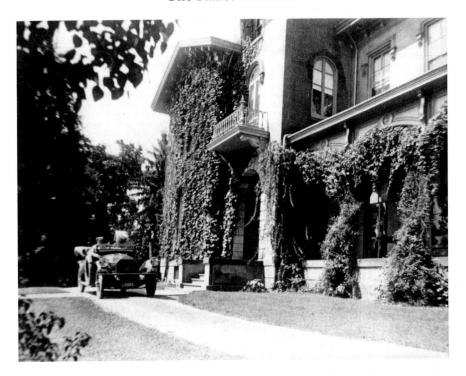

Eddie MacTaggart's Pierce Arrow. *Courtesy of the Washington County Historical Society.*

sophisticated citizen. Never married, Eddie employed a butler named Harry Butler, who was the only person allowed to drive his convertible Pierce Arrow automobile.

Over the years, the Anchorage had become run-down and shabby. Eddie was determined to restore it to its former glory. He hired an army of craftsmen to repair the floors, chandeliers and plasterwork and brought in an interior designer from Chicago to spice up the décor. A world traveler, Eddie had amassed a large collection of artifacts, accessories and expensive knickknacks. Plus, he loved antiques, and he wanted his home to reflect his personality. The decorator gave each room a different theme: the Oriental room, the Queen Anne room, the French room, the Italian Renaissance foyer. He had grand plans to improve the exterior of the Anchorage, as well. Unfortunately, the 1929 stock market crash intervened, and the outdoor project never materialized. The detailed drawings, however, survived and can be seen in the Anchorage today.

Eddie MacTaggart passed away in 1952. After his funeral, which was held in the parlor just as Eliza's had been, Eddie's younger sister, Sophia Russell, moved in. Sophia was almost eighty at the time. According to the papers, she was a "cultural maven having been involved in poetry readings, book, and music appreciation clubs." Nevertheless, she clearly thought that living in the Anchorage elevated her social status. She started insisting that everyone pronounce her name "Soph–eye–a."

Sophia died ten years later. The twenty-two-room house had been more than she could handle. By the time she passed away, the structure was deteriorating at an alarming rate. Sophia's heirs quickly realized that the house was a financial burden none of them could bear, and they offered to sell it to the Washington County Historical Society. Unfortunately, the society was unable to raise enough money. The grand old mansion that had once been called "the Palace Beautiful" became the Christian Anchorage Nursing and Rest Home.

DARK DAYS

By today's standards, conditions in the nursing home were very poor. About fifty patients lived in the facility at any given time. They were crowded into dark, stuffy rooms with little or no privacy. Those who were bedridden or did not receive visitors were housed upstairs. As one former aide put it, once they went up, they didn't come back down. Strips of masking tape with their names still cling to a row of hooks where they hung their bathrobes. At times, an all-encompassing wave of sadness, hopelessness and confusion drifts through the house. Many died, and many more suffered within the walls of the old mansion.

The house suffered, too. The nursing home owners converted the formal dining room into a bathroom by installing toilets and laying linoleum over the parquet wood floor. They rammed supports for acoustical tile ceilings into sculpted plaster moldings and replaced custom-made shutters with cheap venetian blinds. Just when it seemed things couldn't get worse for the Anchorage, they did.

Marietta was the scene of one of the worst nursing home disasters in U.S. history. On January 9, 1970, a patient at the Harmar House Nursing Home, located in the same neighborhood as the Anchorage, tossed a lit cigarette into a plastic trash can. The resulting fire was out of control within seconds. There were no fire doors, no sprinkler system and no way out. Thirty-eight residents died. The National Guard Armory on Front Street became a temporary morgue. It was the only place in town large enough to hold all the bodies.

Legislatures throughout the country moved quickly to pass strict fire and safety regulations. The Christian Anchorage Nursing and Rest Home, along with all other long-term care facilities, made the changes required by the new rules. The solid-core wood doors installed for the Putnams were torn off their hinges and replaced with metal fire doors, lighted exit signs were nailed into to the door frames and holes were punched through the walls and ceilings to accommodate sprinkler systems. Much of the interior damage that visitors see today occurred at that time.

ECHOES OF ELIZA AND LITTLE DOUG

There are still many women in Marietta who worked as aides and nurses in the facility. They did the best they could to care for the patients under very tough circumstances. The fact that the atmosphere in the Anchorage churns with paranormal activity didn't make their jobs any easier.

The women saw ghosts, or to be more precise, they saw a ghost, and every one of them believes it was the spirit of Eliza Putnam. The sightings always occurred during the overnight shift. The witnesses all saw the figure of a woman on the main staircase, which was open in Eliza's day but is now enclosed by dirty walls and rusted metal doors. They describe her as middle aged with dark hair and wearing a long red gown. She stands at the landing, her hand on the remains of the banister, staring. It's as if she is composing herself before making her grand entrance to a party in progress below. Mercifully, she does not appear to have any awareness of what has happened to her beautiful house. People who

live in the neighborhood and those working at the rehabilitation facility next door have seen her, too. Over the years, there have been dozens of reports of a woman standing in the tower of the abandoned mansion.

Since 1996, the year the Washington County Historical Society acquired the Anchorage, most of the encounters with Eliza have occurred in her bedroom, the supernatural bull's-eye of a building brimming with unexplained activity. The historical society grants access to a few groups of paranormal investigators each year. They set up their equipment in Eliza's bedroom, as well as other parts of the house, and spend the night. Most capture orbs, darting lights and other anomalies on still and video cameras. They pick up EVPs, or electronic voice phenomena, energy surges of various sorts and huge temperature swings. Some of the oddest phenomena, though, are experienced by people relying on nothing but their five senses. Many have felt the eerie presence of spirits and heard mysterious noises, including footsteps, voices and laughter emanating from empty rooms and peculiar rhythmic knocks and taps.

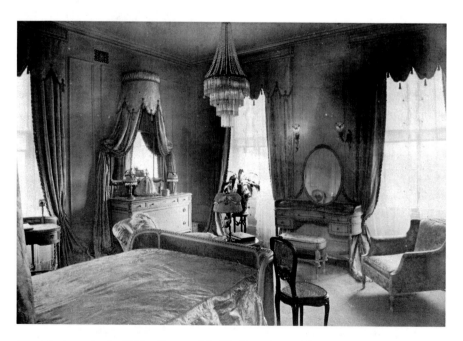

Eliza's bedroom in the 1930s. *Courtesy of the Washington County Historical Society.*

It's tempting to attribute all the activity to Eliza's restless spirit, but there are other candidates. Thick layers of residual energy remain from the nursing home patients, their families and those who tried to ease their suffering. Even people who are not particularly sensitive to residual vibrations tend to pick up on the nursing home energies. Reports of encounters with a Civil War soldier have been on the rise lately, too. Most people sense his presence in Eliza's bedroom.

The soldier may be Douglas Putnam Jr., Eliza's stepson. Little Doug, as the family called him, was a lieutenant colonel in the Ninety-second Ohio Volunteer Infantry. He was seriously wounded at Chickamauga in September 1863 and again only two months later at the Battle of Missionary Ridge. The injuries he suffered at Missionary Ridge were so severe that army doctors did not expect him to survive. A strong and otherwise healthy twenty-five-year-old, he did manage to recover, although his wounds ended his promising military career.

If the ghostly soldier in the Anchorage is Little Doug, this may be a residual, energetic echo of a crisis apparition. Crisis apparitions are generated by people who are dying. In the last moments of life, the dying person reaches out telepathically to a loved one. Crisis apparitions can be visual, audible or come in the form of dreams. The person who experiences the apparition usually interprets it as a form of farewell. In a classic example, a woman dreams of her son, who is fighting in a war zone far from home. He tells her he loves her and assures her that he is now fine. She wakes up and looks at the clock. The next day, she learns her son was killed at the exact moment he appeared in her dream.

The horribly injured Little Doug must have believed his life was coming to an end in November 1863. As he lay delirious in a battlefield hospital, some part of his consciousness reached out to family and home. Everyone who has felt his spirit describes him as filled with sadness. Some believe he's asking for help. Others sense he wants to tell them something. The message crisis apparitions deliver is always the same. It is most likely the message Little Doug is trying to deliver, too: I love you. Goodbye.

The historical society is slowly repairing and renovating the Anchorage. The job is enormous. Current estimates put the total amount needed at $2 million. The society hopes to eventually use the house as its headquarters and as a repository for the documents, photographs and artifacts in its collections. It seems fitting that an organization dedicated to preserving Washington County's history share the mansion with the spirits of people who shaped Marietta's past.

ENGINEERING THE PARANORMAL

Soon after Marietta's founding, Rufus Putnam gave grand—some would say grandiose—Latin names to various features around town. Early settlers and scouts had called the small stream that ran into the Muskingum River Goose Creek. Putnam changed its name to the Tiber after the famous river that flows through the heart of Rome.

Over the years, Goose Creek—or the Tiber, depending on your preference—has caused endless problems. When the Muskingum rises, which it does with regularity, Goose Creek backs up and overflows. Today, that means flooded parking lots and submerged tennis courts at Marietta College, as well as standing water behind several buildings downtown.

In the eighteenth and nineteenth centuries, in addition to being a constant source of minor flooding, Goose Creek represented a health hazard. It was basically an open sewer, and when it overflowed in the warm months, the stagnant pools that remained after the water receded teemed with mosquitoes carrying malaria and other deadly diseases. By 1900, many of the prominent people in town were searching for a way to solve the problem of Goose Creek once and for all. Up stepped wealthy entrepreneur, amateur engineer and man-about-town Colonel J.H. Riley, who announced that he intended to subdue the unruly stream by forcing it underground.

Colonel Riley routed Goose Creek into a nine-foot-wide sewer pipe and buried it under fill he obtained for pennies from the railroads operating in the area. He then constructed a three-story office block on top of the now enclosed submerged creek and, in a nod to the town's founders, named his new building Tiber Way. The building, which still stands along the north side of Butler Street between Front and Second Streets, is gently curved. This allowed trains to run from the Union Train Depot, which was located in what is now a large parking lot on Second Street, to the railroad bridge across the Muskingum.

The citizens of Marietta were impressed with the new building, especially its wonderful ground-floor storefronts and curved façade. But they were most pleased with the fact that Goose Creek and its fetid aroma were no longer part of the downtown atmosphere. Colonel Riley graciously accepted their thanks and praise. He even managed not to blush when the 1900 board of trade called the Tiber Way project "the largest benefit that has been brought to Marietta by a single individual."

Colonel Riley moved into Tiber Way's three-story corner apartment, a splendid unit that sported bay windows and a jaunty brick tower with a pointed roof. He had no problem filling the rest of the space. Several commercial tenants were lined up waiting to move in. No one was more anxious than Dr. V.M. George, a "scientific masseur," who opened a twenty-six-room hospital on the opposite end of the building. The Marietta Sanitarium specialized in the treatment of chronic diseases. Today, it would be called a long-term care facility or a nursing home. The week after the sanitarium opened, Colonel Riley welcomed his second tenant. Doudna Funeral Services moved in next door to the hospital.

Tiber Way wasn't Colonel Riley's only real estate holding. He also owned 203 Second Street, the building adjacent to Tiber Way that now houses the Galley Restaurant. In the early 1900s, the building was called the Riley Block. Directly across the street from the train station, it wasn't long before the Riley Block became the Hackett Hotel. In addition to a restaurant, the Hackett had a popular cocktail lounge and two floors of guest rooms that were used for an assortment of nonsleeping activities by a large contingent of prostitutes.

Ghost ads on the side of the old Hackett Hotel, now the Galley Restaurant. *Photo by Michael Pingrey.*

After the hotel closed many years later, the building fell into disrepair. In the 1980s, a new owner renovated it from the ground up. The first floor was transformed into a restaurant, the second floor became banquet space and the third floor was remodeled into two small apartments. The architect who worked on the renovation tried to retain as much of the building's turn-of-the-century character as possible. He certainly succeeded. In fact, he may have captured a bit more of the past than he intended. A female spirit, whom the restaurant staff calls Charlotte, haunts the premises.

Charlotte is very particular. She doesn't interact with just anyone. She focuses exclusively on men, especially young, attractive bartenders. She loves to interfere with them while they are working. Full bottles of liquor

fall off the shelves, cups and saucers tumble from the bar and wineglasses slide out of overhead racks. Bar towels and dishrags disappear, reappear and vanish again. Is Charlotte flirting? Some of the men who have felt her presence don't think so. They suspect something darker is going on. Perhaps she is trying to retaliate for wrongs she suffered during her nights in the Hackett Hotel.

Regardless of her motivation, Charlotte moves freely throughout the building. The most unsettling encounters with her restless spirit have occurred upstairs. The restaurant's accountant used to work on the books in the second-floor banquet room. He doesn't work on the premises anymore. Charlotte drove him out. He said a feeling of dread often overwhelmed him. It always occurred without warning and was so intense that he felt compelled to leave the building at once.

There is a tiny room, not much more than a closet, on the third floor that contains the electrical box for the apartments. A rattled tenant said that every time he entered the little room, he felt someone's cool breath on the back of his neck. He sheepishly admitted that when the lights flickered out, he often sat in the dark for hours trying to muster the nerve to go into the little room to throw the switch.

There are two unusual aspects to this case. The first relates to variations in the level of paranormal activity. The fluctuations seem to be linked to the restaurant's name. For many years, the restaurant was known as the Adventure Galley. It then became Oliver's and is now called the Galley again. During the Adventure Galley days, the supernatural disruptions were frequent and intense. When the restaurant changed its name to Oliver's, things quieted down. Now that the name the Galley has returned, paranormal incidents are on the rise again.

The second aspect relates to an unusual decorative element in the restaurant. Several antique doors, all of which came from the Hackett Hotel's bedrooms, hang on the back wall of the dining room. People sensitive to psychic and spirit energies suggest that Charlotte's presence is connected to the doors in some way. They say the doors are generating intense vibrations. Perhaps the doors are a portal to another dimension. Or maybe the opposite is true. Maybe the wall of doors is a barrier preventing Charlotte from reaching the other side.

There are supernatural issues next door in Colonel Riley's other building, too, and they may be related to Goose Creek. Ghosts are drawn to underground water sources such as springs, wells, subterranean streams, sewer systems and waterlines. Buildings constructed over water are often said to be haunted, and so it is with Tiber Way.

No one has reported anything unusual on the ground floor, which houses retail establishments, just as it did in Victorian times. The activity is restricted to a few apartments on the top floor. People hear moaning and sobbing. Some have recurring nightmares; others constantly feel nauseous, anxious and edgy. There really is no mystery here. Take the residual vibrations from the Marietta Sanitarium, add a hefty dash of mortuary activity from Doudna's funeral parlor and mix it all together with the spirit-attracting influence of Goose Creek. It's the perfect recipe for the type of disturbed and disturbing atmosphere that people report inside the building.

Colonel Riley was a modern man of science. He would have scoffed at the notion that spirits and underground water are linked. He would have called it superstitious nonsense and brushed it aside, just as he would have done with any suggestion that his plan to control Goose Creek was flawed.

In September 2004, the remains of Hurricane Ivan brought drenching rains and the worst flooding Marietta had seen in forty years. No one realized that Goose Creek's enclosing culvert had been compromised until a large segment of Tiber Way's ground floor caved in. The sinkhole extended from the building's interior to the center of the parking lot. When workers excavated the surrounding area in an effort to stabilize the hole, they found the remains of a wooden footbridge that had crossed Goose Creek in the 1700s. It had been buried under the cheap fill Colonel Riley used in 1900. It's hard to tell what else may be down there.

THE F WORD

On the streets of Marietta, the F word is not the term that usually comes to mind. Marietta's F word is flood.

The Shawnee who lived in the valleys of the Ohio River and its tributaries in the late 1700s knew not to build on the flood plains. They warned the Europeans about the rising waters, but the settlers ignored them and constructed Marietta mere feet from both the Ohio and Muskingum Rivers.

The town was founded in 1788, and the first serious flood occurred in 1790. Torrents of water surged through the city with alarming regularity: 1813, 1832, 1862, 1883, 1884, 1898, 1901, 1907, 1913, 1930, 1936, 1937, 1940, 1943, 1964, 2004 and 2005. Each inundation brought fresh waves of destruction, hardship and misery. In 1832, for example, nine feet of rushing water knocked buildings off their foundations, including the Marietta Firehouse, which ended up in Louisville, Kentucky, six days later.

After the horrible floods of 1883 and 1884, Marietta's desperate citizens were willing to try anything to protect their homes and businesses. They decided to raise the street level downtown, the most vulnerable part of the city. Gangs of workers dumped rocks, bricks, dirt and sand onto Front, Butler and Putnam Streets until each was one story higher.

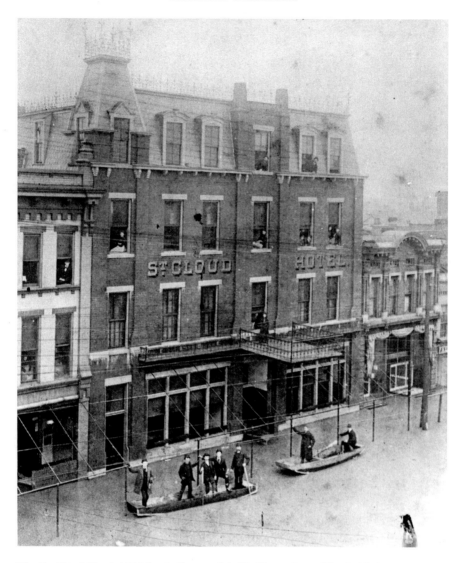

The St. Cloud Hotel, 1884 flood. *Courtesy of the Washington County Historical Society.*

The owners of the buildings that lined these streets had to modify their structures as well. Shop fronts and entrances were suddenly underground, and pedestrians walking along the newly elevated sidewalks peered into what had been second-story windows.

The original first floors, complete with bricked-up doors and display windows, still sit, empty and quiet, beneath many of the old

downtown buildings. Those that had original basements have two stories underground. The underground rooms are not used for anything, not even for storage. It is only a matter of time before they will be filled with water once again.

Elevating the streets helped. Flood damage in the first few years of the twentieth century was not as bad as it had been in earlier years. However, it is not possible to prepare for everything. The cataclysmic flooding of 1913 is a case in point.

The 1913 flood was the worst natural disaster in Ohio history. Like Hurricane Katrina, it demolished the infrastructure that supported society. Railroad tracks around the state were twisted beyond recognition. Telephone poles were snapped like dry twigs, and telegraph wires dangled from tree branches miles from their original locations. Leaking natural gas ignited huge fires, burning those buildings still standing down to the waterline. It's impossible to know how many people died. The best estimate is 468. More than 100,000 were left homeless. An army of dazed refugees, they slept in tents and lean-tos and wandered the streets of their devastated cities searching for food. Property damage exceeded $2 billion in today's dollars.

The disaster began with back-to-back freak storms over Easter weekend. On Good Friday, March 21, a windstorm accompanied by heavy rain lashed the state. Saturday dawned warm and sunny, a perfect early spring day. After winter-weary Ohioans cleared the debris the wind had blown into their yards, they poked around their soggy gardens looking for bright green daffodil shoots. Around dinnertime, a second even more vigorous storm hit. Within hours, temperatures plummeted from the midsixties to the twenties. The saturated ground froze into a solid block of ice. Even though it was below freezing at the surface, heavy rain began falling over the whole state.

The storm continued through Saturday night, all day Easter Sunday, all that night and into the next day, dropping from eight to eleven inches of rain onto the frozen ground. Rushing water cascaded into creeks, streams and rivers already swollen with melting snow. Every Ohio town near a waterway was in danger, and Marietta, nestled between two major rivers, was doomed.

Marietta's St. Cloud Hotel, a favorite of those involved in the lucrative oil and natural gas business, was full when the rains began on Easter weekend. Even though there was telephone and telegraph service, and newspapers ran stories about the wicked weather, it's unlikely that the businessmen staying in the hotel appreciated the seriousness of the situation. Anxious to get back to work the Monday after Easter, they were focused on commerce, not on weather predictions, no matter how dire. They weren't aware that the Muskingum River in Zanesville—only sixty miles upstream—had crested twenty-seven feet above flood stage. They didn't know that an inland tsunami was surging toward their hotel.

When the wall of water slammed into Marietta, the devastation it caused was unfathomable. Every bridge over the Muskingum was destroyed. Hundreds of homes were completely submerged. Cold, muddy water filled basements and then first floors and finally poured through second-story windows of the buildings downtown. People in small boats rowed frantically up and down the streets plucking victims from trees, rooftops and third-story windows.

The guests in the St. Cloud Hotel were marooned. As the water continued to rise, they scrambled to the upper floors. Three oil equipment salesmen counted themselves lucky to be staying on the top floor. Unlike those whose rooms were on the pricier lower levels, they didn't have to move. They stood at their window gaping at the surreal scene below them. They must have realized the significance of what was happening. They may have discussed the fact that the flood was the sort of thing people told their grandchildren about. It must have made sense to open the windows and climb out onto the ledge to get the widest possible view of the destruction.

Moments after the third salesman stepped onto the ledge, it crumbled and broke off the building, plunging all three men into the icy water. Within seconds, they had slipped beneath the surface and drowned.

Marietta was completely cut off from the outside world for seven days. When communications were finally restored, newspaper reporters assured their readers that even though the town had suffered astounding devastation, not a single life had been lost. Local historians agree and insist that no one perished in Marietta during the 1913

The St. Cloud Hotel building in its final days. *Photo by Michael Pingrey.*

flood. Where, then, did the story of the St. Cloud Hotel come from, and why does it persist?

It is possible that the news reports of the time were wrong and that people did die here, but that seems unlikely. A more plausible explanation lies in the circumstances surrounding the flood. Food, fresh water and medical supplies were scarce. Without electricity and phone or telegraph service, it was cold, dark and chaotic. There was no central place people could go for updates and accurate information. Terrifying rumors swirled through town: It's still raining up north! More water's on the way! Reports of fires, disease outbreaks and massive casualties made the rounds, too. The account of the deaths at the St. Cloud grew out of this fear and confusion. Other unfounded rumors from the time faded away long ago, but this story survived because it captures the essence of those awful days in March 1913 in a way that facts and figures never can.

The old St. Cloud Hotel building burned to the ground in the early morning hours of March 22, 2010. Its story is over. The only question that remains is whether the tale of the three salesmen will follow it into oblivion.

ABOUT THE AUTHOR

Lynne Sturtevant has been collecting local legends, superstitions and odd tales—especially those that involve paranormal elements—since childhood. A Marietta resident and certified ghost hunter, she is the creator and lead guide of Ghost Trek, a popular walking tour of historic and haunted downtown Marietta. She also conducts tours of the area's

Lynne Sturtevant in the Colony Theatre. *Photo by Michael Pingrey.*

ancient earthworks and offers special programs and events throughout the year. Ms. Sturtevant is a frequent guest on WMOA radio and is an active member of Marietta's Convention and Visitors' Bureau. For more information, visit www.hiddenmarietta.com.

Visit us at

www.historypress.net